JOSEPH WRIGHT

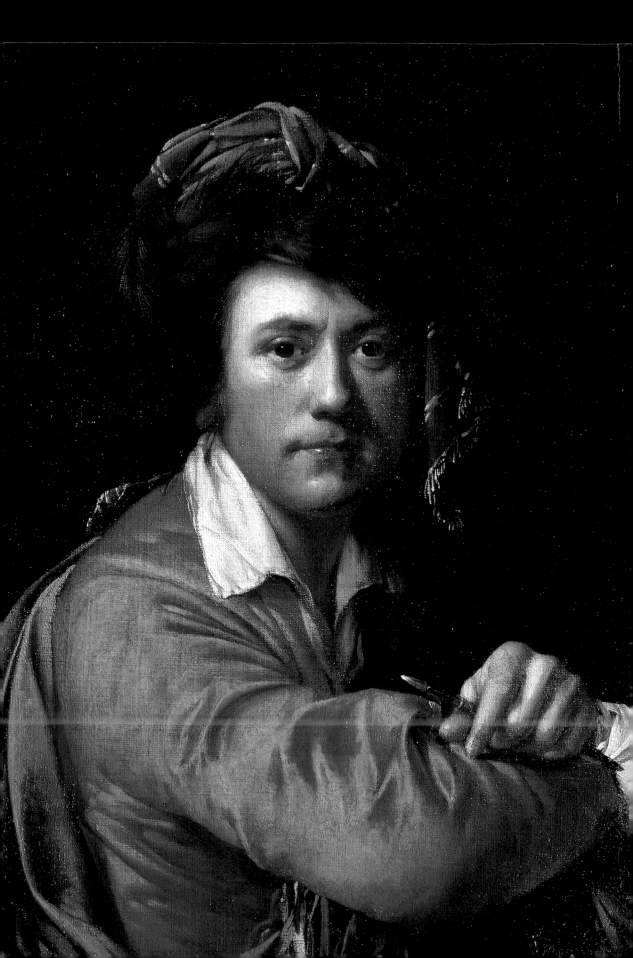

JOSEPH WRIGHT

Stephen Daniels

British Artists

Princeton University Press

For Jessica and Ruth

Acknowledgements

I wish to thank David Fraser, Richard Humphreys and Jane Wallis for their comments on the manuscript. I am indebted to the scholarship of a number of other researchers on Wright and eighteenth-century culture; their works are listed in the Bibliography.

Stephen Daniels

Front cover: *Vesuvius in Eruption ...* c.1776–80, detail (see fig.50)

Back cover: *The Alchymist ...* dated 1795, detail (see fig.16)

Frontispiece: *Self-Portrait c.*1772–3, detail (see fig.18)

Published by order of the Trustees of the Tate Gallery by
Tate Gallery Publishing Ltd
Millbank, London SW1P 4RG

Published in North America by
Princeton University Press
41 William Street
Princeton NJ 08540

ISBN 0-691-02943-1
Library of Congress Catalog Card Number: 99-61246

Cover design by Slatter-Anderson, London

Book design by James Shurmer

Printed in Hong Kong by South Seas International Press Ltd

Measurements are given in centimetres, height before width, followed by inches in brackets

CONTENTS

INTRODUCTION:
ART AND ENLIGHTENMENT

Joseph Wright (1734–97) painted some of the most powerful pictures of eighteenth-century British art: blacksmiths hammering a glowing bar of iron, dramatic demonstrations of scientific apparatus, a large factory illuminated at night, erupting volcanos, gloomy prisons, the widow of an Indian chief lamenting on a stormy mountain, a fashionably dressed gentleman reclining full-length in a forest. This study focuses on the compelling diversity of these pictures, together with some more apparently conventional examples of Wright's art, in relation to the cultural movement in eighteenth-century Europe known as the Enlightenment.

What was the Enlightenment? The traditional view, expressed in the eighteenth century, was of a modernising, liberating movement dispelling a dark age of religious superstition, political tyranny, social exclusion and emotional repression through the power of reason, creating a brighter and better future for mankind. The torch-bearers of truth were an intelligentsia – moral philosophers, educational reformers, liberal economists, political theorists, experimental scientists – whose writings aimed to explain and improve the natural and social fabric of the world. Historians of the Enlightenment have tended to focus on continental Europe where the forces of light and darkness were starkly contrasted and the powers of enlightenment vested in a consciously intellectual avant-garde. At the time, however, as Roy Porter has pointed out, French and German intellectuals looked to England as the enlightened country: a liberal, creative environment where their ideals were widely discussed and, moreover, put into practice. A limited monarchy and rational religion provided an orderly basis for freedom of thought and enterprise; turnpike roads and canals the framework for movements of goods and ideas; coffee-houses, taverns and Masonic lodges a forum for exchanging views; factories, showrooms, lecture theatres and playhouses places for producing wealth, knowledge and pleasure; paved and lighted streets and neatly enclosed fields were a landscape planned according to progressive views. The forging of 'Britain' as a nation state was identified as an enlightened project, integrating the progressive places of England, Scotland and Wales. The British Empire was upheld as an enlightened undertaking, spreading the virtues of commerce and civilisation, opening new fields of exploration and enquiry.

In Britain the centres of debate that were the basis for the development of Enlightenment culture took many different forms in different places: medicine here, fashion there, elsewhere music, watercolour painting, nature writing, philanthropy, public building, factory building and experi-

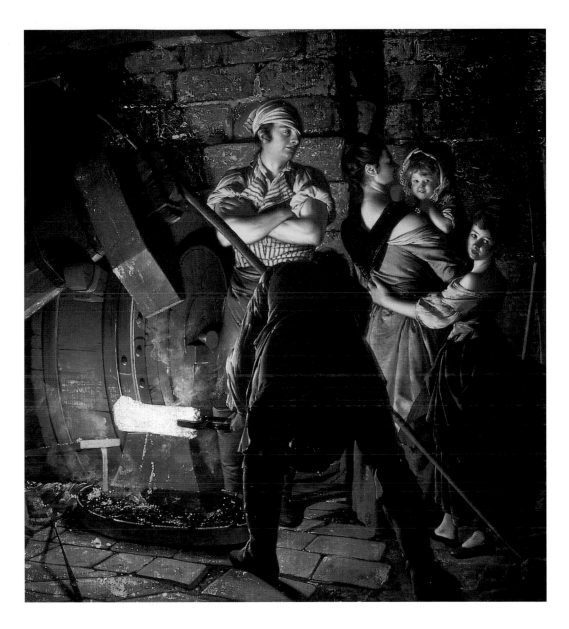

1 *An Iron Forge*
1772, detail
(see fig. 38)

mental science. Some places, notably the polite precincts of commercial towns and cities and some landed estates, were arenas for many forms of enlightened culture, but this is not to say that it was an insular, establishment ideology. The Enlightenment was consciously lived as well as imagined, applied and marketed as well as theorised and discussed throughout Western Europe. It was valued as a material, commodified world of clothes, ornaments, furnishings, paintings, shops, gardens, fields and tourist sites in addition to being a network of intellectual exchange. An enlightened sensibility was a key characteristic of 'polite society', a powerful consensus between landed, trading and professional classes vested in private property and commercial enterprise. Polite society valued,

7

not least financially, a refined appreciation of the world, its appearance, working and meanings: both the world which it inhabited, of fine houses, pleasure grounds and civic squares; and the other worlds it did not, of the urban and rural poor in Britain and of exotic cultures overseas. Much eighteenth-century English art and literature catered to such tastes.

Looking at the Enlightenment as a field of knowledge and practice, a broad, complex and contested one, we can begin to position eighteenth-century English art and the work of Joseph Wright. Almost by definition, as professionals producing accessible art for polite society, many painters participated in enlightened culture; but their engagement differed greatly in degree and kind. George Stubbs's anatomical studies informed his portrayal of the improved pedigree of English country life, in sleek race-horses, dogs and livestock set in smooth parkland, as well as the imported beasts – monkeys, leopards and moose – kept in the gentry's menageries. Paul Sandby pioneered watercolour drawing in his role as a mapmaker, working on the Military Survey of Scotland and teaching at the Royal Military College, Woolwich. Accompanying Captain Cook on his voyages, William Hodges documented the flora and fauna of the South Seas with a botanical eye and later made his living in India painting the landscape with scholarly attention to its native culture. George Romney painted the professional classes, especially women and children, deploying a modern neo-classical style fashionable in the radical political circles in which he mixed.

It is useful to distinguish investigative, interdisciplinary art such as this, depicting the new worlds of the eighteenth century from domestic childhood to overseas landscapes, from that associated with the Royal Academy, founded in 1768. Under the presidency of Sir Joshua Reynolds, and influenced by Reynolds's published *Discourses*, the Academy urged painters to study old masters and set their sights on the elevated art of history painting, scenes from literature, the Bible or classical antiquity. At issue was not the subject-matter of history painting – many artists portrayed such scenes, many for the print market – but its style. Academicians were urged to paint in the grand manner portraying through their narratives noble, timeless, heroic virtues. In separating the fine arts (painting, sculpture, architecture) from the mechanical arts (engraving, technical drawing, decoration) the Royal Academy proved a contentious institution. Some painters, Wright, Romney and Stubbs among them, stayed loyal for as long as possible to the consciously com-mercial Society of Artists which admitted artists of all kinds and was keen to protect their professional standing. There was a radically patriotic, anti-establishment edge to quarrels with the Royal Academy. Artists resented both its royal patronage and its ranks of foreign-born exhibitors such as Johann Zoffany, Henry Fuseli, Benjamin West, Philip de Loutherbourg and Angelica Kauffman. It is nevertheless difficult to draw a clear line between academic and non-academic art in terms of Enlightenment culture. The Royal Academy was an educational institution, its exhibitions were open to polite society, its high-minded theoretical programme was hard to identify

in many of the pictures. Such artists as Fuseli and Loutherbourg were attuned to Masonic currents of Enlightenment thought and Kauffman was a pioneering professional woman artist who took on themes usually reserved to men.

How do we position the art of Joseph Wright? Many interpretative issues are implicated in his common name 'Wright of Derby', which he was dubbed early in his career when he moved from his home town in the Midlands to Liverpool, to distinguish him from another Wright in the city, Richard Wright, now a little-known marine painter. After he had made his reputation in London, Wright continued to use the name in publicity, rather like a trademark, and in private letters to clients and friends. He was clearly committed to his home town and its regional culture, and he never moved permanently to London.

Derby was not a provincial backwater, but an enterprising technical, commercial and cultural centre. The town mobilised its region's natural resources of metals, minerals and water-power in the crafts of instrument-making, wrought ironwork and gemstone-cutting as well as the heavier industries of china-making, iron smelting and textile manufacture. The skills of Derby's builders, ironworkers and engineers were evident in surrounding country houses and gardens as well as in its town houses and assembly rooms, the venues for polite society. Derby had strong connections, by canal and road, to the booming cities in the West Midlands and North West – Birmingham, Liverpool, Sheffield – and to its many smaller industrial, commercial and cultural centres – industrial sites such as Coalbrookdale and literary towns such as Lichfield. Indeed, during the period of Wright's career this region provided a counterweight to the power of London, commercially and culturally, redefining relations between art and manufacture, practical and speculative knowledge.

Joseph Wright was born in Derby in 1734 into a professional family, the third son of John Wright, an attorney known as 'Equity' Wright because of his reputation for fair dealing. His eldest brother John followed his father into the family law practice, his elder brother Richard set up as a physician in their home town. After demonstrating a talent for drawing from a young age, Wright was sent to London in 1751, aged 17, to train for two years in the most marketable form of painting, portraiture, in the costliest apprenticeship in London, the studio of Thomas Hudson. After a further fifteen months of study with Hudson in 1756–7, he established a portrait-painting practice in and around Derby. From 1765 to 1773 Wright made a striking impact in London with exhibits at the Society of Artists: dramatically lit night scenes of figures focusing on objects – a cast of classical sculpture, scientific apparatus, the anvil of iron forges – contemplating issues of knowledge and power. For three years or so, he was based in Liverpool where he painted portraits of the merchant community. In 1773 he left Derby for Rome for two years in the company of his new wife, Hannah or Ann. A local woman, but it seems from a lower class than the Wrights, Hannah did not meet with the approval of his family, and the sojourn in Italy seems something of an elopement as well as a period of study. Here in

Rome Wright's first child Anna Romana was born and he embarked on a sustained study of landscape, antiquities and High Renaissance art. Wright's family blamed the various physical and mental ailments from which he suffered in later life on protracted periods of drawing Michelangelo's figures from the ceiling of the Sistine Chapel. Upon his return to England Wright spent twenty months trying unsuccessfully to establish himself in genteel Bath, in the wake of Gainsborough, as a fashionable artist. Bath was a place where Enlightenment values of enquiry and industriousness were at best marginal: Pump Room society, and the flattery it demanded, scarcely suited Wright's sensibility. In 1777 he returned to Derby for good, extending his range of subjects to include land-scapes, mythological scenes and portraits of nationally famous Midlands figures. Doubtless there was an element of civic pride and family feeling in the move, but it was connected to the fact that it was possible to make a prosperous living in the place. Like other Midlands entrepreneurs Wright continued to use London as a place to meet people and to market his work, to forge both a regional identity and an international reputation. With the Society of Artists in decline he exhibited at the Royal Academy and was elected an associate member, but quarrelled with the Academy shortly afterwards. He exhibited in Liverpool and then in London in a one-man show. His pictures continued to command high prices, both as exhibited or commissioned oils and as fine engravings.

In every place, at every stage of his career, Wright associated and exchanged ideas with men (and it was mostly men) accomplished in many fields of enlightened culture. In his first residency in Derby he was close to clockmaker and geologist John Whitehurst and mapmaker and engraver Peter Perez Burdett. It was Burdett who encouraged Wright to follow him to Liverpool and who helped secure him commissions on the Continent. When in London Wright stayed with engraver William Pether, one of a group of radical figures he socialised with in the capital, which also included architect James Gandon and painter John Hamilton Mortimer. Wright was not himself a member of the Lunar Society, the liberal Midlands fraternity of philosophers and scientists, but he knew a lot of men who were, notably pottery entrepreneur Josiah Wedgwood and the polymathic Erasmus Darwin, physician, educationalist and botanist. Wedgwood, Darwin, Burdett and Whitehurst were Freemasons, attending London lodges, and it is probable that Wright was too. In Rome Wright befriended George Romney and upon his return to England the progressive poet William Hayley, who encouraged Wright's portrayal of literary and mytho-logical themes. In his later years in Derby, Wright was close to Darwin (who had moved to the town in 1781) and the poet and watercolourist the Reverend Thomas Gisborne, who lived outside the town in Needwood Forest. Both tried to alleviate Wright's later illnesses, Darwin through hot baths, Gisborne through long walks.

These various associations help explain a defining feature of Wright's work, its deployment of an unusually wide range of pictorial and written sources. As well as modern works, newly published novels and poems,

newspaper reports, travel literature, peep-show transparencies, educational treatises, moral tracts, essays in political economy and scientific diagrams, Wright drew on an older tradition of hermetic knowledge in sixteenth- and seventeenth-century images and texts. The appearance and meaning of Wright's paintings were shaped both by illusionistic forms of commercial entertainment and by mysterious cabbalistic texts. The light of pure reason was but one of the sources of illumination in Wright's art.

While Wright eagerly and sometimes anxiously consumed the ideas of multitalented men, he himself was singlemindedly a painter – proudly, professionally so. He drew on a range of knowledge to improve his technique, whether constructing an apparatus of folding screens in his painting room to produce the effects for artificially lit night scenes or experimenting with pigments and brushwork to render lighting, mood, topography and space. As Rica Jones has shown in her analyses of Wright's materials and techniques, he painted like no other leading artist. He laid down white ground to reflect light through layers of darker paint, in the case of some metallic light sources (e.g. a lamp and molten ingot) through gold and silver leaf, and used brilliant pigments such as vermilion and Naples yellow for his luminous outdoor scenes. It is characteristic of Wright, as a technically and commercially minded artist, to list the contents of a palette in his account book. It is also characteristic of his adventurous outlook that he copied it from an unusual source, *The Practice of Painting and Perspective Made Easy* (1752) by Thomas Bardwell, an East Anglian drawing-master unconnected to the London art world. In the introduction Bardwell explained that he had made a long study of old masters, especially Rembrandt, to discover the secrets of their colouring, and claimed to have recovered technical methods which had been lost. In matters of technique as well as imagery, Wright forged an innovative art, with the capacity to portray key subjects of the modern world through recovering the mysteries of the past.

Wright's career stretches from the 1760s, a period of general optimism within English polite society about the progressive potential of enlightened culture, to the 1790s when war with revolutionary France (a state proclaiming Enlightenment ideals) fractured cultural opinion between radicals and reactionaries. It is important for Wright's work to be considered as part of a wider debate about knowledge and power, looking at how his art probes the conflicts and fault lines within polite culture, searches the shadows of the Enlightenment. Of particular interest is the way Wright uses a variety of genres – figure painting, subject painting and landscape – at various stages of his career to explore the world of the Enlightenment, its social and geographical diversity, connections and divisions. Releasing Joseph Wright from a restrictive view of his regional identity should help explain why he commanded a considerable international reputation in his lifetime and, arguably more than any of his contemporaries, continues to do so now.

1

FIGURES OF FEELING

Wright's work is dominated by figure painting. He left Derby as a young man to train for three years in London with the most successful portrait painter Thomas Hudson, and when he returned for periods in the mid-1750s and early 1760s made a good living depicting men, women and children, alone and in small groups, from the professional classes and middling gentry in Derby and the East Midlands. Although Wright diversified his work into genre scenes, history painting and landscapes, he continued to undertake and to exhibit portrait commissions throughout his career.

Through its very productivity and profitability, with standardised prices for various picture sizes (full-length, half-length and so on), portraiture was often denigrated as low-grade hack work, 'one of the staple manufactures of the British empire' as the history painter Benjamin Haydon called it. Wright was one of a group of artists, including Thomas Gainsborough, Romney and Reynolds, who revived and refined English portraiture as a fine art, using it to convey a variety of traditional and modern sensibilities. Wright's figure drawings during periods of study in London and Rome display the finer characteristics of British manufacturing culture. His chalk sketches of costumed figures done in Hudson's studio show a marvellous eye for textiles, for the look and fabrication of silk and lace (fig.2). His drawings in Rome of nude and semi-draped figures from the antique and High Renaissance (fig.3), largely in pencil and pen-and-ink, are in the linear neo-classical style which was then a hallmark of modern industrial design, for textiles, interior decoration, book illustration and most famously Wedgwood china.

Wright's figures are distinguished by their complex paintwork, in the expressive portrayal of the tone and texture of hair, flesh, clothes and accessories. He was highly attentive to the material appearance, structure and styling of various fabrics, metals and gemstones. If Wright is to be regarded as a painter of the Industrial Revolution, it should be as much for his depiction of buttons and bows as of mills and machines. Industrialisation was driven by demand for consumer goods. The textile mills of the Midlands were famous for their fabrics, from fine silks to plain woollens, the metal factories for their buckles and buttons. Wright carefully portrays the skilled handiwork, the cutting and stitching, fitting and refitting, that went into the making of clothes. It is as if his own technical accomplishment with paint mirrors that of the makers of costume.

Wright carried his skill in portraiture into his genre and history painting. Most pictures are dominated by a few figures, sometimes only one, who

 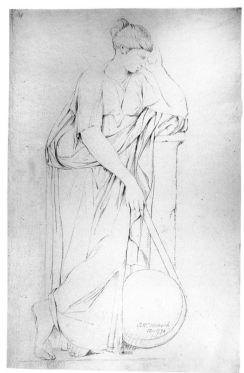

2 Study for
Wright's *Portrait of
Elizabeth Wright*
*c.*1755 7
Chalk on paper
29.2 × 22.9
($11\frac{1}{2}$ × 9)
Derby Museum and
Art Gallery

3 *Study of a Muse,
after the Antique*
1774
Pencil and charcoal
on paper
52.4 × 33.7
($20\frac{5}{8}$ × $13\frac{1}{4}$)
Derby Museum and
Art Gallery

look like identifiable people, often like those in his portraits, as well as strik-ing the appropriately heroic poses to personify more abstract allegorical themes or play their role in narratives. This made the pictures marketable to a middle-class audience, not just the relatively wealthy ones who pur-chased the canvases but also the many who bought the engravings. Engraving was esteemed at the time as an enlightened medium, for multi-plying and circulating artworks to a wide audience. Like Wedgwood with his pottery, Wright was concerned to exercise a high degree of quality control; he maintained close, often personal, relations with his engravers.

Like many artists, Wright used stock poses for his figures, especially from prints. They could be chosen from a repertoire expressing various desirable character traits. Wright looked beyond the usual patrician postures and gestures to more meditative poses, sometimes from arcane sources. Thus Wright's figures possess a psychological and emotional complexity absent from most aristocratic portraits. Many eighteenth-century portraitists showed sitters with props signifying their cultural and social identity. Aristocratic sitters posed with classical texts, heroic busts, or glimpses of their country houses and parks. Wright rarely showed such insignia, even for his landed patrons. Most are posed with emblems of activity, even enterprise, a shining piece of galena (lead ore), a bolt of muslin, a model of a spinning machine, a portfolio of drawings, a quill pen poised in the act of writing, a telescope for surveying, a plan for a town house, a riding whip, a book marked 'Rental'. Wright's sitters were not all merchants and industrialists; there were also clergymen, country squires and literary

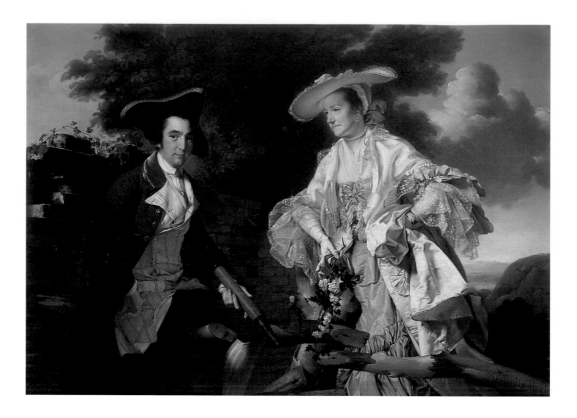

men, but most wished to be portrayed as participants in the inventive enterprise culture of the time. It was a culture which regarded commerce as a source of virtue throughout society, for widening opportunities of leisure and learning, for freeing human relations, aspirations and feelings and for reckoning with the real world. It is through the physical, material appearance of Wright's figures that we appreciate not only the quality of their character as people and relations with each other, but their embodiment of some of the feelings and sensibilities that characterised the Enlightenment in England.

The double portrait of Peter Perez Burdett and his wife Hannah (fig.4), a gift to the couple, signifies Burdett's contribution as a cartographer to the cultural life and reputation of Derby, and also challenges some of the conventions of the marriage portrait. Burdett holds a telescope, a symbol of the survey of Derbyshire he was making

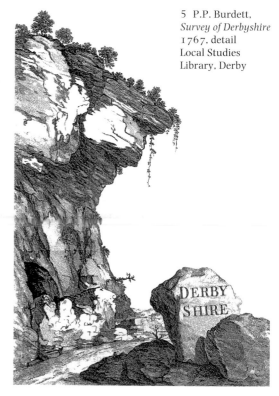

5 P.P. Burdett,
Survey of Derbyshire
1767, detail
Local Studies
Library, Derby

4 *Peter Perez Burdett
and his wife Hannah*
1765
Oil on canvas
145 × 205
(57⅛ × 80¾)
Národní Galerie,
Prague

at the time. He was awarded a premium of £100 from the Society of Arts for planning a systematic new county survey with accurate instruments, at a standardised scale, showing major routes for 'the ease and advancement of the national commerce'. Like the Society's other awards for innovations in the applied arts, from farming machines to furniture designs, it recognised a prototype for patriotic progress. Burdett literally put Derbyshire on the map, confirming its position at the centre of the world of technical expertise and the applied arts. His new map of the county accurately positioned Derbyshire within a universal system of co-ordinates, determined the exact position of every place by a trigonometrical survey and charted the exact route of each road and the mileage of the major ones.

Burdett's map was engraved and published in London in 1767 and sold in both London and Derby for a guinea, a little more expensive than fine engravings of modern paintings such as Wright's. It was a complex, consciously commercial image. Not only did it show routes and resources, especially forges and mines, but it omitted the most prominent features of conventional county maps, landowners' names and parks (significantly these were added in a second edition of 1791, long after Burdett had sold the plates and left the country, and during a period of patrician reaction). The map included a detailed plan of Derby showing its commercial and civic development, a triangulation diagram 'for the use of the curious in Geography', and a cartouche (fig.5) showing a carefully drawn, picturesque crag through which a road has been driven, probably that at the entrance to Matlock Dale. In contrast to the crude maps of Derbyshire available to London audiences, with their confusing cartography and vignettes of such Peak District wonders as 'The Devil's Arse', Burdett's map clarified and refined the image of the county, revisioning it as a centre of advanced, educated knowledge.

Burdett's award from the Society of Arts was a fraction of the cost of the survey, which took him four years or more to complete. He received loans from Wright, which were never repaid in full, and probably a good deal of support, in cash and kind, from other local figures. During the survey Burdett resided at Staunton Harold, seven miles from Derby, the country house of the leading Freemason and astronomical enthusiast Lord Ferrers (Ferrers purchased Wright's *The Orrery* (fig.24), a painting in which Burdett is portrayed). During the map's production and sale Burdett moved to a new house in Derby a few doors from Wright. A good deal of the cost of the survey was funded by his marriage to the woman shown in Wright's double portrait, Hannah Wansell, widow of a wealthy Midlands merchant. This was Burdett's second marriage. Little is known of his first marriage or anything about his life or work in Manchester before he came to Staunton Harold around 1760, perhaps initially to survey the estate Lord Ferrers was in the process of improving, to help draught architectural designs, and, as the portrait in *The Orrery* implies, to assist in his astronomical speculations. Burdett met Hannah Wansell shortly afterwards and they married in 1761.

Wright's painting of the Burdetts breaks the proprietary and sentimental

conventions of marriage portraits. There is little engagement between the pair or between them and the scene in which they are set. He looks laconically at, she stares impassively past, the spectator. He holds a telescope, a sign of the survey the marriage contract helped fund, limply in his hand; she holds a sprig of hawthorn blossom, a standard sign of bad luck, for it flowers only for a day. The fence between the couple is broken, the wall behind is crumbling. Hannah Burdett wears a fashionable milk-maid-style bonnet but is overdressed for an outdoor portrait; her husband is not attired for the country at all. In the relations between the figures, and between the figures and their surroundings, Wright portrays the failure of stable, companionate marriage with as much virtuosity as he showed its success in his double portraits for other friends, Thomas Coltman and Thomas Gisborne. On the back is an inscription which, in its cryptic and superior style, is characteristic of Burdett's writing to Wright:

> The portraite, of Peter Perez Burdett
> and Hannah, his Wife: being
> ye admirable performance
> of Friendly Testimony,
> of Joseph Wright of Derby
> Whose merit as a Painter
> is exceeded by his Worth as
> a Man: as his Art is exceeded by Nature.

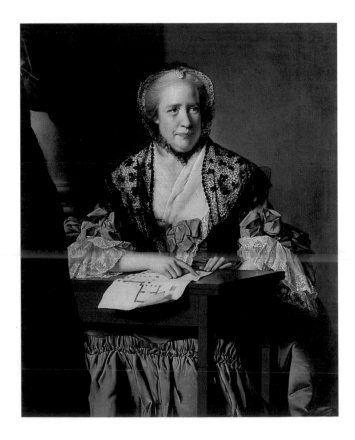

6 *Mrs Sarah Clayton c.*1769
Oil on canvas
127 × 101.6 (50 × 40)
Fitchburg Art Museum,
Fitchburg, Massachusetts,
Gift of Louise I. Doyle

7 A Conversation of Girls (Two Girls with their Black Servant) exhibited 1770
Oil on canvas
127 × 101.6
(50 × 40)
Private collection

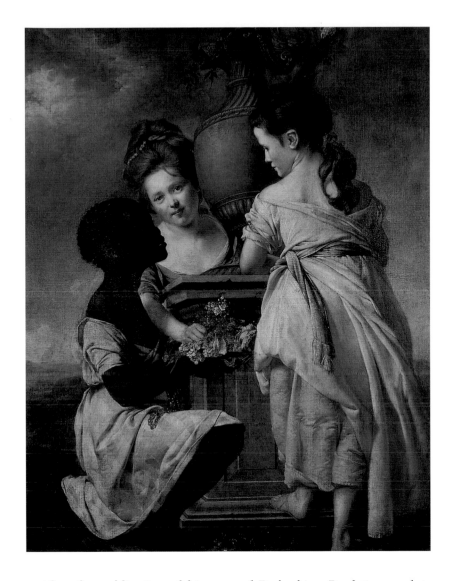

After the publication of his map of Derbyshire, Burdett moved to Liverpool, to speculate on its dramatic commercial progress through its growing control of Atlantic trade. Burdett expanded his graphic enterprises to publish maps, plans, views and descriptions of the new emporium and its region. He founded the Liverpool Society of Arts, taught perspective drawing and embarked on a series of experiments in pictorial reproduction, notably aquatinting, which he may have espied during a trip to France, and transferring aquatints chemically to pottery, which he developed through its contacts with the Warrington Academy, a centre of dissenting knowledge, and tried to sell to Wedgwood through their Liverpool associates.

Wright followed Burdett to Liverpool, finding clients for portraits among the entrepreneurs of the city. *Mrs Sarah Clayton* (c.1769) (fig.6) shows a woman, a spinster despite the honorary title, who was one of the

leading business figures in Liverpool, the main entrepreneur in the coal industry, the city's leading property developer and promoter of public buildings. In Wright's portrait she holds the plan of her house as the centrepiece of her civic designs, Clayton Square. A forceful, formidable figure in Wright's portrait, she points to the plan and fixes her gaze past us, as if on some further commercial or civic prospect. Burdett did not subscribe uncritically to Liverpool's commercial success. He was, like many of Wright's circle, a critic of the slave trade. Wright's picture *A Conversation of Girls (Two Girls with their Black Servant)* (fig.7), exhibited at the Society of Artists in 1770, puts a conventional form of aristocratic conversation piece into question. A ship appears on the horizon, one of the white girls grabs the slave girl's offering, and the slave herself while kneeling in a submissive posture is figured in abolitionist style, as in Wedgwood's famous cameo reproduced in Erasmus Darwin's *The Botanic Garden*: 'On bended knee', as Darwin put it, 'from Britain's sons imploring to be free' (fig.8).

Wright returned to Derby in 1770 but Burdett continued to keep in close touch, giving technical advice on the drawing and detail of settings for some of Wright's subject pictures, notably the equipment in *The Alchymist* (fig.16) and a perspective of a barn, perhaps the setting of one of the forge scenes, and aquatinting one of Wright's paintings of boys inflating bladders. Through his extensive network of international contacts, probably through Masonic circles, Burdett helped secure clients for Wright, notably Catherine the Great for *An Iron Forge viewed from without* (fig.39). In Liverpool Burdett's speculative ventures began to founder. He was forced to sell the recipe for aquatinting and, after Wedgwood's rejection, offered the secrets of his 'chemical experiments' for printing on porcelain to Benjamin Franklin in Philadelphia and to Frederick the Great of Prussia. Burdett eventually found a patron in the Margrave of Baden, from the same Masonic order as Lord Ferrers. After succeeding to his title, the Margrave wished to have his territories surveyed and appointed Burdett to the rank of captain in charge of a cartographic team based in Karlsruhe. 'Mr Burdett has sold his goods and is off,' Wright reported to his brother from Rome in 1774. 'Mrs Burdett and her dear Miss Fredried are gone into lodgings, over head and ears in debt. I stand no chance of being paid at present – well, if ever ...'. Burdett took Wright's double portrait with him to Baden. It is not clear when Hannah Burdett followed, or when she died. In 1787 Burdett married for the third time, to Friedericke Kottewski, perhaps Hannah's 'dear Miss Fredried' to whom Wright referred in his letter.

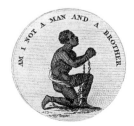

8 Josiah Wedgwood, *'Am I not a Man and a Brother?'* Cameo engraving, in Erasmus Darwin, *The Botanic Garden* 1795, canto 2.

9 *Francis Noel Clarke
Mundy c.*1762–3
Oil on canvas
127 × 101.6
(50 × 40)
Private collection

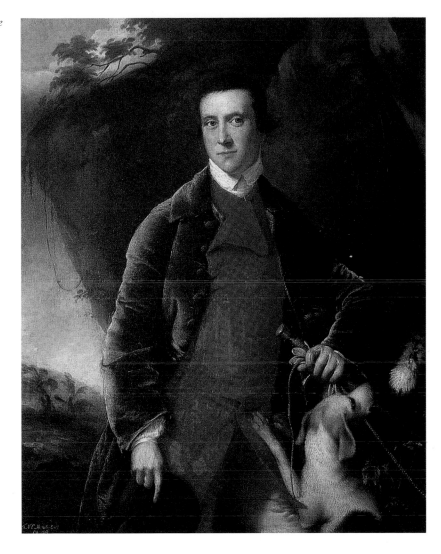

If the mobile, mercurial Burdett represented the speculative, cosmo-politan face of the Enlightenment, another friend and subject of Wright's portraiture, Francis Noel Clarke Mundy (fig.9), squire of Markeaton Hall, just to the west of Derby, represented its more rooted, agrarian face. Conventionally enough the portrait of Mundy was commissioned upon the sitter's inheritance of the family seat and its estates, and shows the new owner as a huntsman, a traditional image of landed pleasure and power. Moreover young Mundy followed his late father's example of commission-ing this portrait as one of a set of sporting portraits of him and his friends to hang in the dining-hall. Against an urbane literary and pictorial tradition representing field sports as backward, boorish and dissolute, Wright has, like his contemporaries Stubbs and Gainsborough, modernised the hunting portrait, showed the huntsman as a cultivated figure, relaxed yet dignified. The difference with Wright is in the nature of the sport. Francis Mundy is

not portrayed, like his father and friends, or like most modern sitters, as a gun-toting shooter of game birds, nor as an aristocratic hunter of deer. He is presented as a figurehead of the newly invented and highly fashionable Midlands sport of fox-hunting.

Because foxes were not game (in a county where the game laws were strongly defied by the populace) and were regarded largely as bloodthirsty prowlers, even by the urban animal welfare movement, fox-hunting was the least controversial of field sports. It was welcomed, indeed subscribed to by a wide range of rural and urban types, including farmers and lawyers, women as well as men. They enjoyed the speed of the chase, with fast horses and hounds, and the close-cut and brightly coloured clothes. Fox-hunting was a smart, flashy pastime. Like urban assemblies, fox-hunts were one of the fashionable rituals for forging the consensus of polite society, and like newly built or renovated town halls and assembly rooms, the making of fox-hunting country, with its coverts and trimly hedged fields, was part of the modernisation of the landscape. Mundy is shown as master of his newly instituted Markeaton Hunt, in a smart new livery, crop in hand, hound by his side, and, by the hound's muzzle, a fox's tail, or 'brush', the master's trophy. The cliff behind is not so much an identifiable feature of Mundy's estate as a motif of Derbyshire, like the similar one drawn on the vignette of Burdett's county map. In the rest of the portraits, Mundy's friends, striking fashionably informal poses, lounging on chairs and fences, a cap tossed on a tree stump, a crumpled handkerchief spilling from a pocket, show off the newly commissioned livery, royal blue velvet jackets, scarlet waistcoats and yellow breeches. The set of six portraits destined for Markeaton Hall was first exhibited in Derby Town Hall, displaying the style of Mundy and his friends, including Wright, to a wider audience.

Mundy was a cultivated country gentleman. While at New College, Oxford, he acquired from one of his hunting friends, Harry Peckham, a taste for poetry, and after taking up residence on his estate became part of the literary circle at Lichfield, a proudly provincial gathering with a radical edge. The circle's leading figures Anna Seward and Erasmus Darwin persuaded Mundy to publish his poem *Needwood Forest* on the ancient forest between Derby and Lichfield. Published in Lichfield in 1776, it was said by Seward to be 'one of the most beautiful *local* poems that has ever been written'. The poem mounts a defence of the ancient liberties as well as extolling the scenic attractions of the forest, and includes a description of a fox-hunt in which the predatory fox is figured as an ageing 'tyrant' and the pursuing huntsmen and hounds as a band of freedom fighters:

> When Freedom's voice alarms the morn,
> And vengeance winds her echoing horn ...
> All striving with confederate aim,
> Their size, their power, their speed, the same ...
> Through woods, and hills, mid vales and brakes,
> NEEDWOOD with general transport shakes.

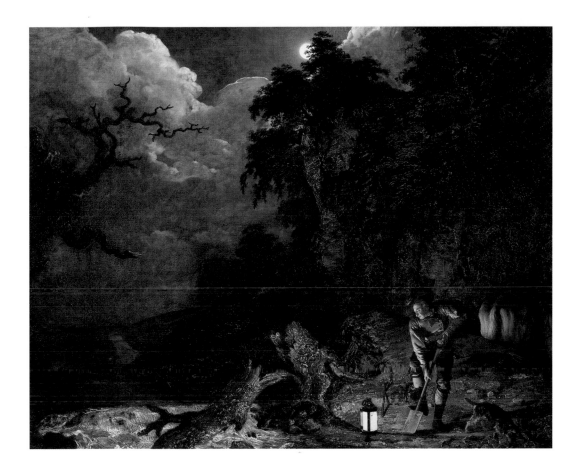

10 *The Earthstopper on the Banks of the Derwent*
exhibited 1773
Oil on canvas
96.5 × 120.6
(38 × 47½)
Derby Museum and
Art Gallery

Mundy included a description of a preparation for the hunt, with the earthstopper filling up foxholes at night while the fox itself is out hunting, cutting off its escape in the morning from the chasing huntsmen and hounds.

> Night, when rude blasts thy scenes deform ...
> While the moon labouring through the clouds
> By turns her light reveals and shrouds ...
> His lantern gleaming down the glade,
> One, like a sexton with his spade
> Comes from their caverns to exclude
> The mid-night prowlers of the wood ...

Wright had already portrayed such a scene in *The Earthstopper on the Banks of the Derwent* (fig.10), exhibited at the Society of Artists in 1773. There are echoes of some of Stubbs's sporting pictures in the idea of portraying a hunt servant and the anatomically exact hindquarters of the tethered white horse. The earthstopper himself is portrayed less like one of Stubbs's submissive, immaculately costumed gamekeepers or grooms, more like one of Wright's industrious, independent blacksmiths in the moonlit forge scenes he exhibited in London at this time. Wrapped up

against this stormy night, in a hand-me-down velvet jacket and trousers worn with work, he puts his back into the task, with a spade that the light from his lantern shows is both cracked and carefully repaired (fig. 11). Wright poses the earthstopper against a similar crag to that in his portrait of Mundy, but now rendered more 'sublime' in the style of the popular seventeenth-century painter Salvator Rosa. The picture presents the power of the Derbyshire countryside to a London audience.

The portrait of Brooke Boothby (1781) (fig. 12) shows another fashionable, indeed radically chic country pursuit, the contemplation of nature. A Derbyshire landowner and one of the Lichfield literary circle, Boothby is shown reclining full-length by a stream in a woodland glade, holding a vellum-bound volume with the lettering 'Rousseau' on its spine. The book refers to Boothby's claim to fame, his editing and publication in 1780 at Lichfield, in French for the first time anywhere, of the *Première Dialogue* of the philosopher's posthumous testament, *Rousseau Juge de Jean Jacques*. The exiled Rousseau had stayed in Staffordshire in 1766–7, after the publication of *Emile*, his educational tract on the civilising influence of

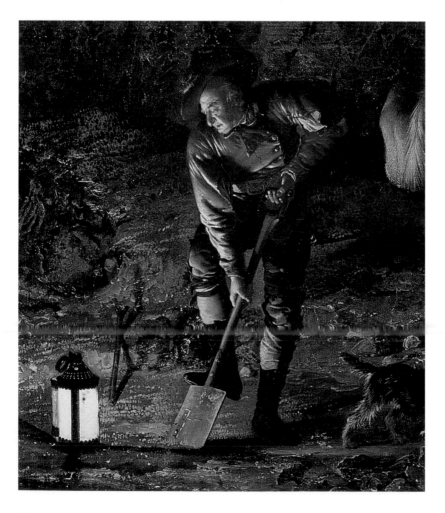

11 *The Earthstopper on the Banks of the Derwent* 1773, detail (see fig. 10)

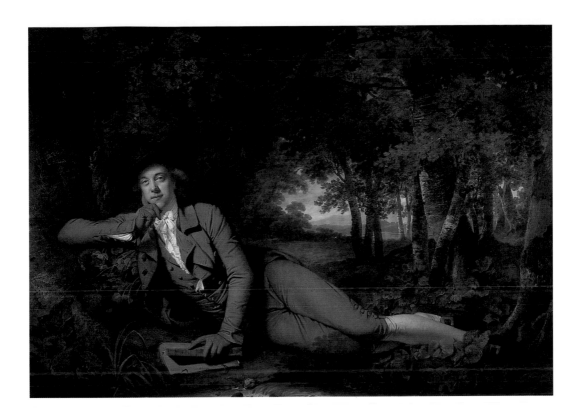

12 *Brooke Boothby*
1781
Oil on canvas
148.6 × 207.6
(58½ × 81¼)
Tate Gallery

nature, had caused a sensation in England and converted many of the younger men of the Lichfield circle into ardent disciples. When Boothby passed through Paris ten years later, the elderly *philosophe* entrusted him with the manuscript of his autobiography which Boothby published in Lichfield two years after Rousseau's death.

Some of Wright's contemporaries, notably Gainsborough, had shown young men lolling casually against trees but Wright was the first to show an English gentleman lying full-length in the countryside. As Desmond Shawe-Taylor points out, Boothby strikes the pose of the hero of Henry Mackenzie's Rousseauvian novel *The Man of Feeling*, who 'lay himself down ... on the banks of a rivulet ... stretched on the ground his head resting on his arm'. Like a faithful disciple, Boothby is dressed in plain, informal clothes which favour healthy walks, and has closed the book, the better to reflect on the natural world around him and to enjoy his reverie. Wright has also, as Frederick Cummings has shown, revived an Elizabethan convention of portraiture, the Man of Melancholy, which persisted into the eighteenth century largely in tomb sculpture and inscriptions and in contemporary engravings of Renaissance prints (fig.13). The key text for this is Robert Burton's *Anatomy of Melancholy* which prescribes walking 'alone in some solitary grove, betwixt wood and water, by a brook side, to meditate upon some delightsome and pleasant subject, to melancholize ... to go smiling to themselves'. The blend of ancient humour and modern

23

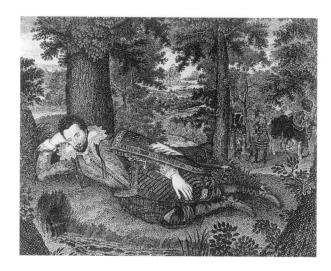

sensibility is wittily appropriate to the sitter. In his later political writings, Boothby linked the virtues of feeling and melancholy, drawing 'a distinction between the natural passions of man and those factitious passions which are the produce of society', and urging men to 'retire to melancholy meditation on the fleeting vanities of the world'. Like most fashionable Men of Nature, Boothby was also a Man about Town, and played an important role promoting Wright's work in London.

The theme of captivity recurs throughout Wright's art, in scenes of people incarcerated in dungeons, mines and caverns, animals in chains, cages and jars. Indeed the enclosed, vessel-like structure of so many of Wright's settings functions to contain, for better or worse, many of his figures: hermits in grottoes, smiths in forges, nature lovers in woodland groves, families in the various rooms of their houses. They are figures of reflection, both theirs and ours.

The Captive, from Sterne (1774) (fig.14) depicts a literary scene of incarceration, from Laurence Sterne's novel *A Sentimental Journey* (1768), which had recently enthralled the English reading public. The captive is not an actual person encountered by the novel's narrator on his journey through France to Italy, but rather one imagined when he discovers he has lost his passport in Paris, and is visited by the police. Initially making light of being 'clapp'd up into the Bastille', the very symbol of arbitrary state power, the narrator is captivated by the song of a bird in a cage, 'I can't get out – I can't get out', and addresses himself 'to LIBERTY'. Sitting down at his table, head in hand, 'I began to figure to myself the miseries of confinement':

> I took a single captive, and having first shut him up in his dungeon, I then look'd through the twilight of his grated door to take the picture. I beheld his body half wasted away with long expectation and confinement ... Upon looking nearer I saw him pale and feverish: in thirty years the western breeze had not fann'd his blood – he had seen no sun, no moon in all that time ... I saw the iron enter his soul.

14 *The Captive,
from Sterne* 1774
Oil on canvas
102 × 127.5
(40⅛ × 50¼)
Vancouver Art
Gallery

Wright painted the picture in Rome, after his own journey from the nation the enlightened throughout Europe upheld as the land of liberty, and his discovery, like that of many before him, of a humanist classical heritage which contrasted with contemporary Catholic superstition and political tyranny. Wright's captive is not figured as a common felon or a dissolute debtor, like Hogarth's scene of *The Rake in Fleet Prison*. Like his earlier picture, *A Captive King*, he is a man of dignity and status. The figure in *The Captive, from Sterne* is influenced by Michelangelo's frescos in Rome, resembling the listless body of Christ crucified. A later version shows the Sterne captive sitting in the posture of Adam on the ceiling of the Sistine Chapel. In both pictures Wright portrays the captive as a modern Man of Sorrows, one who promises through his suffering to loose his bonds and come to life.

In the late 1780s Wright exhibited a series of enigmatic 'small prison scenes' (fig.15), with tiny, slumped figures, mere signs of humanity, dwarfed by vaulted cells. These images have echoes of Giambattista Piranesi's monumental scenes of incarceration, and may have their origin in cells in the Capitol in Rome (one of which Wright drew in a picture since lost). A more precise correspondence is to John Howard's writings on prison reform. Some of Wright's circle at this time, notably Darwin and

15 *Small Prison
Scene c.*1787–90
Oil on canvas
40.5 × 47 (16 × 18½)
Yale Center for British Art,
Paul Mellon Collection

the poet William Hayley (who composed an ode to Howard) were active supporters of the reform movement. Howard did not object to imprisonment as a punishment, rather to its common conditions, in dank, dark, overcrowded, disease-ridden gaols and bridewells. He favoured the construction of structurally sound, highly regulated prisons with spacious, well-lit cells, in which criminals could be transformed into penitents. 'Solitude and silence are favourable to reflection; and may possibly lead them to repentance,' observed Howard in *The State of the Prisons in England and Wales* (1777); 'Privacy and hours of thoughtfulness are necessary for those who must leave this world.' Wright's small prison scenes echo Howard's description of the condemned cells at Newgate – the vaulted walls, the grated windows, the barrack bedstead – and convey something of the crushing effect they were designed to have. Condemned men who 'affected an air of boldness' in the public theatre of their trial, observed Howard, 'were struck with horror and shed tears when brought to these darksome solitary abodes'. The only sign of life outside Wright's prison scenes is a church steeple glimpsed through the window, focusing the prisoner's thoughts and ours.

The Alchymist (fig.16) portrays many cross-currents of Enlightenment culture. First exhibited at the Society of Artists in 1771, it is one of a series of dramatic night scenes with which Wright made his mark in the London art world, and, through fine engraving, his international reputation. These nocturnes show small groups of people gathered around a brilliantly lit artefact – a sculpture, scientific apparatus, an ingot of iron – people intently working and witnessing, their faces strikingly illuminated in a spectrum of expressions. These nocturnes are each in their way concerned with processes of change and transformation, in the objects observed and in the subjects who observe them.

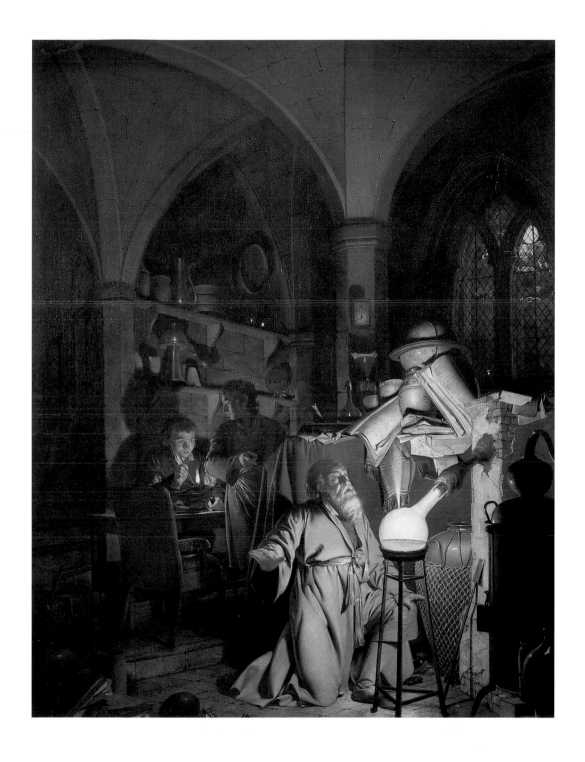

16 *The Alchymist, in Search of the Philosopher's Stone, Discovers Phosphorus, and prays for the successful Conclusion of his operation, as was the custom of the Ancient Chymical Astrologers* exhibited 1771, reworked and dated 1795 Oil on canvas 127 × 101.6 (50 × 40). Derby Museum and Art Gallery

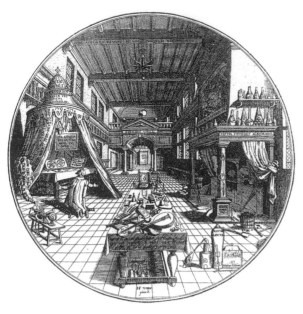

17 Heinrich Khunrath,
Laboratorium
Engraving in
*Ampitheatrum Sapientae
Aeternae* 1602

The Alchymist is close to the series of forge scenes, in having the main object itself as a source of light (rather than a reflection of candlelight) and having it illuminate details of the interior in which the work takes place. *The Alchymist* proved less successful as a commercial proposition than the forge scenes and did not sell upon exhibition. Wright took it to Italy with him but failed to sell it there either. He brought it back in 1775 when it was then published and exhibited as an engraving but still did not find a buyer. He offered it to the pottery manufacturer Josiah Wedgwood, who thought it less appropriate for his house in Etruria than the one he commissioned from Wright of *The Corinthian Maid* (fig.40), a scene of classical mythology set in a pottery. *The Alchymist* remained in Wright's studio. He reworked and redated it twenty years later, shortly before he died, but did not, as far as we know, offer it for sale again.

Wright spelled out the exact process portrayed in the painting in its full title: *The Alchymist, in Search of the Philosopher's Stone, Discovers Phosphorus, and prays for the successful Conclusion of his operation, as was the custom of the Ancient Chymical Astrologers.* Wright drew on a variety of sources for the picture. He took details of the production of phosphorus, the white vapours in the retort and the jet of bluish light issuing from it, from recent chemistry books, probably Pierre Joseph Macquer's *Elements of the Theory and Practice of Chemistry* (translated into English in 1758 by James Keir). Burdett, then conducting his own chemical experiments in Liverpool, sent Wright annotated sketches of the apparatus, its arrangement and the architecture of the crypt-like setting. The astrolabes and open alchemical books are taken from seventeenth-century Dutch paintings, probably from Thomas Wyck's pictures of meditative alchemists, one of which Wright owned and treasured. The figure of the alchemist in Wright's painting, his arms raised in ardent prayer, is drawn from an engraving

(fig.17) in a highly influential text of spiritual alchemy, Heinrich Khunrath's *Ampitheatrum Sapientae Aeternae* (*Amphitheatre of Eternal Wisdom*) (1602).

Each of these sources is, in different ways and to different degrees, respectful of alchemy. The manufacture of phosphorus in the seventeenth century was seen by modern chemists such as Macquer as a productive outcome of a misdirected material pursuit, the manufacture of gold. Wright's alchemist, like Khunrath's, is not greedy for gold, rather engaged in a spiritual quest for the philosopher's stone, the source of wisdom. This was not immaterial. Some chemical enthusiasts in Wright's time, notably Freemasons Erasmus Darwin and Joseph Priestley, cleaved to the notion of alchemy as a progressive, materialist religion, in opposition to the priest-craft of their day and its cloaking of human greed and oppression. Alchemy had long been satirised in art and literature, even in the sixteenth century

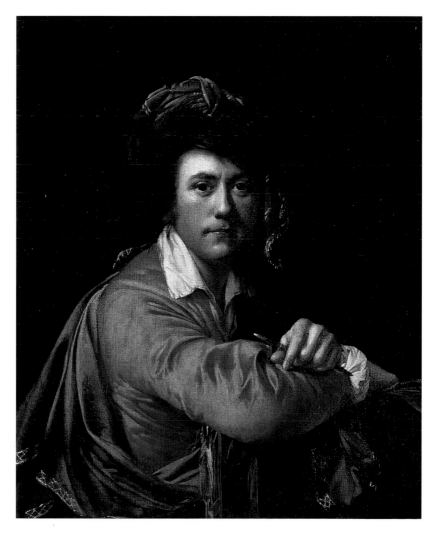

18 *Self-Portrait*
c.1772–3
Oil on canvas
76.2 × 63.5
(30 × 25)
Private collection

when it commanded more mainstream cultural esteem than it did in Wright's time. In chaotic workshops, wearing tattered robes, and with crazed expressions, the alchemist was a figure of ridicule, his craft mere hocus pocus. Wright cleans up the alchemist's act. His workshop is like Khunrath's 'laboratorium', a place of labour and prayer. He wears a spotless robe with silken sash, his expression, that of a saint or disciple in Christian art, is one of devotion and transfiguration. The scene expresses what the inscription above Khunrath's alchemist announces: 'Ne Loqua ... Des Deo Absq Lumine' ('Do not Speak of God without Light').

Wright may have painted his alchemical scene to oppose strategically another exhibited in London the previous year, Zoffany's painting of a scene from a recently staged version of Ben Jonson's satirical play *The Alchymist*, showing David Garrick in the role of Abel Drugger, and the ridiculous ingredients of his art. Wright's painting stages a counter-theatre to Zoffany's, or rather a different genre of theatre, not just to the painting but to the institution where it was exhibited, the Royal Academy and its ethos of separating the fine from the mechanical arts. Like the forge scenes Wright exhibited at the rival Society of Artists, *The Alchymist* dignifies a low subject, turns a technical operation into a noble pursuit. In Masonic terms it presents a 'chemical theatre' of material and spiritual transformation.

How did Wright portray himself? There are ten recorded self-portraits, done at various stages of his career and presenting Wright in various guises. Two self-portraits from the early 1770s, probably done in Rome, are highly theatrical, reflecting his role as a student of art. One, as an artist,

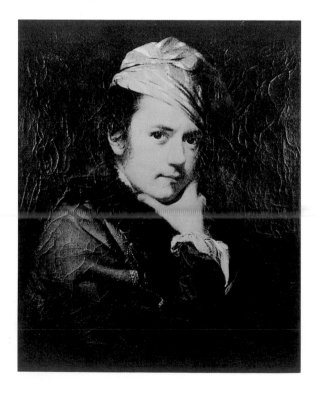

19 *Self-Portrait*
c.1773
Oil on canvas
71.1 × 60.9
(28 × 24)
Private collection

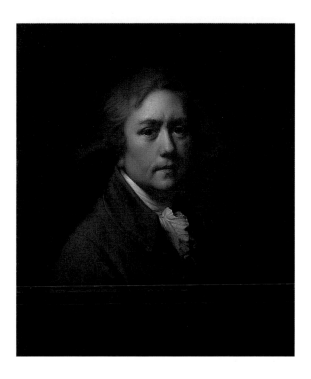

20 *Self-Portrait*
*c.*1782–5
Oil on canvas
61.6 × 52.7
$(24\frac{1}{4} \times 20\frac{3}{4})$
National Portrait
Gallery, London

is Rembrandtesque (fig.18). As is the case with some of Rembrandt's self-portraits, Wright dons exotic garments and headgear and with it the mantle of creative genius; he holds a *porte-crayon* (a sketching pencil with black and white chalk), a sign of the Dutch master's command of chiaroscuro, the dramatic deployment of light and shade, which Wright sought to emulate. In the other picture (fig.19) Wright poses as a turbaned brigand, in the style of his friend and fellow artist John Hamilton Mortimer, and in the persona of another seventeenth-century painter they both ardently admired, Salvator Rosa. Rosa was reputed not just to depict banditti but to be one himself, as he was rumoured to have participated in the scenes of magic and witchcraft he painted. The banditti of the hills around Rome, who preyed on Grand Tourists, appealed to rebellious English democrats such as Mortimer. Wright also seems to have cut an exotic figure. Reporting his arrival in Rome with his paintings *The Alchymist* and *Captive King* and his refusal to have his first child Anna Romana baptised, an English priest wrote to Lord Arundell: '[Wright] is here suspected of being a Jew, or Annabaptist, or something else that is not a Xtian.'

Wright's subsequent self-portraits, after he returned to England and to Derby, are not so showy, but even as an apparently respectable professional man, Wright remained something of a rebellious outsider. Suffering prolonged bouts of illness, much of it chronic depression, he was quarrelsome, even cantankerous in his dealings, especially with pompous metropolitan men. There are echoes of Rembrandt's later self-portraits in Wright's, in their melancholy expressions of age and infirmity (fig.20).

2

THE PLEASURES OF THE IMAGINATION

Wright made a dramatic impact on the art world of the 1760s with a series of 'Candlelight Pictures', scenes of small groups of people concentrating on some object in darkened interiors, their faces and expressions brilliantly illuminated by a candle flame. The style of nocturne was derived from the works of seventeenth-century Dutch and Italian painting, often from devotional art. Wright used it to transform two popular, if somewhat hackneyed, genres of eighteenth-century art, the fancy picture and the conversation piece. Fancy pictures were generalised, consciously charming portraits, often of middle-class children and young women with playthings, perhaps toys, pets, books or flowers; most were produced for a mass market, in the form of engravings, whose titles and accompanying verse brought out their lightly allegorical allusions. Conversation pieces were usually commissioned works showing family groups posed in the rooms or grounds of their houses, usually with various objects, such as artworks, globes, gamebirds and venerable trees, which signified their cultural pedigree. Wright's Candlelights transform these images of pleasure and propriety into something more profound and more unsettling.

The darkened, dimly differentiated interiors of Wright's Candlelights, may, as David Solkin suggests, allude to John Locke's metaphor of the mind as a 'dark room' to which the eye lets in images of the external world to be stored and reflected upon. Locke's writings on knowledge, education and civil society, were, after the Bible, the most profoundly influential texts for eighteenth-century polite culture. Most people assimilated their insights through more recent, more accessible writings, poetry, periodical essays, novels and teaching texts. Wright's Candlelights depict a sensibility that Joseph Addison first characterised in a series of essays for the *Spectator* as 'the pleasures of the imagination':

> Our sight is the most perfect and most delightful of all our senses. It ... furnishes the imagination with its ideas; so that by the pleasures of the imagination ... I here mean such as arise from visible objects, either when we have them actually in our view, or when we call up their ideas into our minds by paintings, statues, descriptions, or any the like occasion.

Wright's very first exhibited picture, *Three Persons Viewing the Gladiator by Candlelight* (fig.21), shown at the Society of Arts in 1765, portrays the virtues of Addison's 'Man of Polite Imagination' who is 'let into a great many pleasures that the vulgar are not capable of receiving': 'He can converse with a picture, and find an agreeable companion in a statue.' Three men, two young, one older, scrutinise a small-scale cast of the statue of the Borghese Gladiator, a canonical masterpiece of antique art (models

21 *Three Persons Viewing the Gladiator by Candlelight*
exhibited 1765
Oil on canvas
101.6 × 121.9
(40 × 48)
Private collection

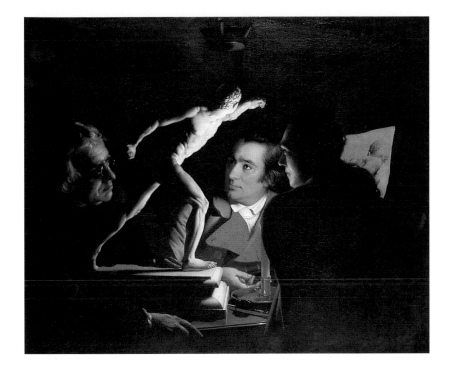

like that on the table were available for around thirty shillings, an affordable price for most professional households). The Borghese Gladiator was admired in the eighteenth century for both its concrete and abstract virtues, for its anatomical truth in showing the thrust of the gladiator as he overcame his opponent, and in representing an ideal, smoothly muscular, masculinity. Wright's painting also extends an invitation to understand it in terms of its concrete and abstract virtues, a group of three recognisably real men with expressions of rapt observation which mark them as men of polite imagination. Who these persons viewing the Gladiator were modelled on, if anyone, might not have concerned most London exhibition-goers or purchasers of the engraving, but probably mattered to the painting's purchaser, Benjamin Bates. A former resident of Derby, Bates moved to Buckinghamshire to practise as a physician, put together his art collection and take part in the most notorious cultural gathering of the time, the Hell Fire Club. A friend of Burdett and patron of Mortimer, he would have recognised the two young men in the picture as Burdett and Wright.

The men in *The Gladiator* admire, as women and children were thought incapable of admiring, this work of art, this naked embodiment of sublimity. It is instructive to compare the manly imagination represented in *The Gladiator* with the representations of feminine fancy in Wright's nocturnes. *Two Girls Dressing a Kitten by Candlelight* (c.1768–70) (fig.22) shows two girls who seem to have strayed from the nursery to play on the finely polished table on which the men view the Gladiator. They have taken the clothes from their doll and started to dress the kitten. One girl holds the kitten grotesquely, and immodestly, on its hind legs for our inspection,

the other smiles naughtily and knowingly at us. *A Girl reading a letter by Candlelight, with a Young Man peering over her shoulder* (c.1760–2) (fig.23) reworks another stock theme of fancy pictures. Pictures of adolescent girls reading and writing alone in closets, small private rooms designed for such pursuits, often had a prurient atmosphere from the licentious fantasies that novels or letters were presumed to encourage. The young woman in Wright's picture may have an etiquette book entitled *The Art or Guide of Writing a Letter* by her side, but what we see of the letter she writes, 'Dear Jack', her name on the envelope of his letter 'Miss Eliza Jeltem' (jilt 'em ?), her knowing smile and the alarmed expression of the man who is trying to look over her shoulder, suggest she is using her accomplishment to pursue the pleasures of an independent life.

Wright offers a comprehensive analysis of the pleasures of the imagination in *A Philosopher giving that Lecture on the Orrery, in which a lamp is put in place of the Sun* (fig.24). An orrery is a planetarium, a mechanical model of the solar system in which the orbits of the planets and their moons are turned by clockwork. The machine Wright depicts is a Grand Orrery, embellished with concentric armillary hemispheres which give the instrument height and an impressive appearance. Costing over £200, it was an expensive instrument, a luxury item, and indicates the status of the scene. The brass ball which usually represents the sun has in this lecture been replaced by a lamp wick in a jar of oil, to demonstrate an eclipse or the transit of a planet across the sun.

Addison incorporated the insights of Newtonian natural philosophy in the pleasures of the imagination, extending its powers 'to survey the whole earth at once, and the several planets that lie within its neighbourhood', a theme taken up in a series of long poems, notably Mark Akenside's *The Pleasures of Imagination*. The lamp in Wright's *Orrery* illuminates the faces of a group of men and women, young and old, viewing this model of the solar system and envisioning, in Addison's words, 'the several planets ... so many worlds ... sliding round their axles in such an amazing pomp and solemnity'. The spectators have, as it were, left their separate pursuits, the children put away their toys, the young woman her letter, the young men their statue, to listen to a lecture on

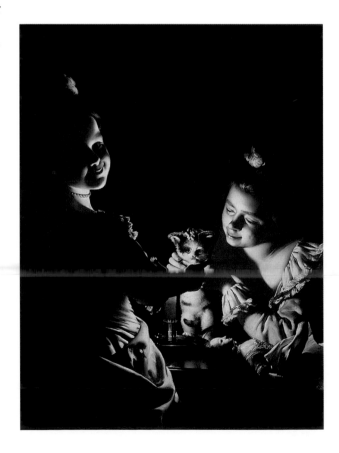

22 Two Girls Dressing a Kitten by Candlelight
*c.*1768–70
Oil on canvas
90.8 × 72.4
($35\frac{3}{4} \times 28\frac{1}{2}$)
Private collection

23 *A Girl reading a letter by Candlelight, with a Young Man peering over her shoulder*
c.1760–2
Oil on canvas
88.9 × 69.8 (35 × 27½)
Private collection

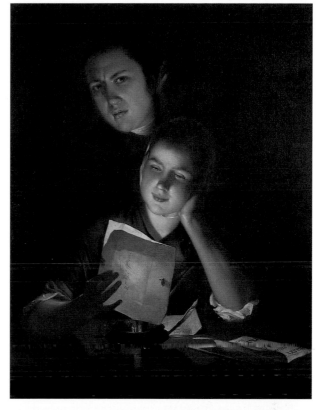

24 *A Philosopher giving that Lecture on the Orrery, in which a lamp is put in place of the Sun*
exhibited 1766
Oil on canvas
147.3 × 203.2 (58 × 80)
Derby Museum and Art Gallery

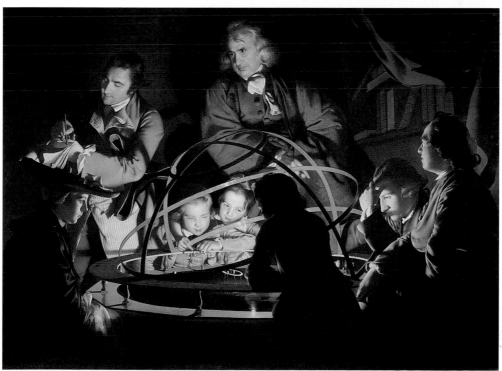

the solar system and survey its cosmic harmony. The orrery was an instrument which, in the words of Addison's fellow essayist Richard Steele, 'administers the Pleasures of Science to any one'. Wright portrays the visible cause and effects of this pleasure, both differentiating the various capacities and interests of the spectators and integrating them in a close social circle.

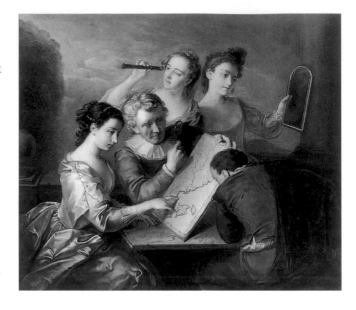

As an image of enlightenment *The Orrery* operates on a number of levels. The picture reworks paintings of visual and graphical, specifically geographical, knowledge. One source is Philip Mercier's painting *Sight* (fig.25) from his series on the senses (*c.*1744–7). This shows a group of young people around a map held by a man who seems to be delivering a geography lesson of some kind. The two young women behind him hold up optical gadgets, a telescope and a mirror. Women holding mirrors were conventional figures of vanity, but this woman angles the mirror away from her face to reflect what her companion observes. This is geography, in the words of a popular textbook of the time, as 'the most useful, agreeable and entertaining of Sciences ... It shows us as in a Glass, the whole world, brings every part into our view'. This is not a timeless allegory. The map the seated figures pore over is a modern one of the western Mediterranean and coast of Spain, where Britain was battling imperial rivals in Europe for ascendancy as a world power. Many such maps of British theatres of war were published, in periodicals as well as individual prints, marketing the expanding empire for domestic consumption, establishing the link between geography, education and citizenship. They were part of a cartographic craze in eighteenth-century Europe. The schoolrooms and libraries of prosperous households were equipped with maps of various kinds, maps on puzzles and in primers, as well as the atlases and globes which appear in conversation pieces. Pietro Longhi's *The Geography Lesson* (*c.*1752) shows members of a Venetian household looking sensually at each other rather than at the maps; the lesson of the picture is that such empires as that of Venice were lost through luxury and idleness.

Geography was the basic subject of Locke's seminal educational curriculum. Its field of vision formed a framework for the teaching and development of other subjects, from astronomy to history. A young child could learn 'which is the *AEquator*, which the *Meridian*, &c. which *Europe* and which *England* upon the Globes, as soon almost as he knows the Rooms in the House he lives in'. The children in *The Orrery* have evidently

25 Philip Mercier, *Sight*, from *The Senses c.*1744–7 Oil on canvas 132 × 153.6 (52 × 60½) Yale Center for British Art, Paul Mellon Collection

progressed in Locke's curriculum from 'the Terrestial Globe' to 'be entered in the Celestial', to be shown 'a Draught of the Copernican System' 'to understand the Motion and Theory of the Planets'. 'So proceeding by gentle and insensible steps, Children without Confusion and Amazement, will have their Understandings opened, and their Thoughts extended farther, than could have been expected.' In Wright's time a series of illustrated manuals, some especially for girls, was published to introduce Locke's higher realms of natural philosophy, notably *The Newtonian System of Philosophy* (1761) by Master Tom Telescope (thought to be written by Oliver Goldsmith). The girl in *The Orrery*, with her arm around a boy, probably her brother, points out the orbit of one of the moons around Saturn (fig.26), as the lecturer above her points to the same motion around another planet.

The Newtonian theory of universal gravitation, as demonstrated on this cosmic scale, was used to articulate a range of social, spiritual and political concerns. The faces of the figures around the orrery reflect the light at different angles, in a progression like the phases of the moons and planets they observe, establishing a connection between the social and cosmic worlds that Anglican theologians saw in Newton's principle of attraction. As physical bodies gravitated towards one another, orbiting at various distances, so did people through varying degrees and kinds of sympathy from intimate childlike affection, as represented by the brother and sister, to more patriarchal benevolence represented by the philosopher. The Newtonian model of the universe informed Masonic formulations of the world as an orderly structure designed by the Divine Architect. The guiding

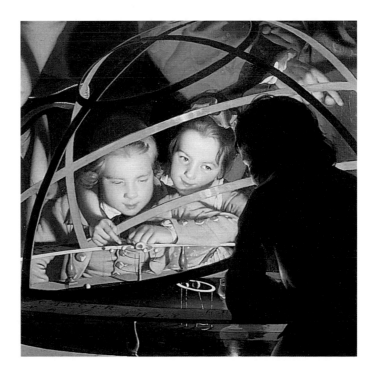

26 *A Philosopher giving that Lecture on the Orrery, in which a lamp is put in place of the Sun* exhibited 1766, detail (see fig.24)

force of eighteenth-century British Freemasonry, the itinerant lecturer J.T. Desaguliers, geared universal gravitation to the Whig vision of limited monarchy. The principle of attraction bound sun and planets, monarchs and ministers.

> What made the planets in such Order move,
> He said, was Harmony and mutual Love.
> The Musick of his Spheres did represent
> That ancient Harmony of Government.

Wright's image of the lecture alludes to the many demonstrations of natural philosophy to mixed audiences by itinerant lecturers using cheaper, portable apparatus. Spectacular display was seen as crucial to securing the appeal of science, but there was concern, especially with audiences, which included women and children, of bedazzling rather than enlightening them, confusing serious demonstrations with conjuring tricks, lecturers with showmen. Wright's painting, set in a private library, with expensive equipment, presents a carefully regulated spectacle, establishing a contrast with the more flamboyant, explicitly commercial performances of scientific knowledge in playhouses and coffee-houses. The lecturer, at the apex of the composition, is a quietly authoritative figure, his face recalling portraits of Newton.

In the nineteenth century, the figure of the lecturer was identified by one of Wright's old associates as that of Derby's leading instrument-maker and Newtonian natural philosopher, John Whitehurst. Wright portrayed Whitehurst twenty years later (fig.55) and while, allowing for age, there may be some resemblance between the two faces, to blend the images of Newton, the national hero, and Whitehurst, the local hero, would have been a nice conceit. The figure taking notes was identified by the same source as Burdett, which is confirmed by Wright's double portrait of Burdett and his wife (fig.4) made around the same time. Again, as far as their function as figures is concerned, for exhibition-goers or purchasers of engravings their possible identity as real people may not have mattered. But the identity of the painting's purchaser, Lord Ferrers, one of the Derby circle of savants, and the fact that he seems to have reserved the picture make the circumstances of the painting significant.

A former admiral and naval architect, Washington Shirley, 5th Earl Ferrers, pursued his interests in astronomy at his country seat Staunton Harold, about seven miles from Derby, and took an active role in the cultural life of the town and its region. He was also a major figure in metropolitan circles. In 1761 he was elected a Fellow of the Royal Society for his observations on the transit of Venus and 'other useful discoveries tending to the improvement of mathematical knowledge'. He presented to the Society an orrery he had invented 'to facilitate the conception of future transits'. Active in Masonic circles, Ferrers was in 1762–4 appointed Grand Master of English Freemasons in the Lodge of Strict Observance. Burdett resided at Staunton Harold at the time of this picture while he conducted his survey for his Map of Derbyshire, pioneering astronomical

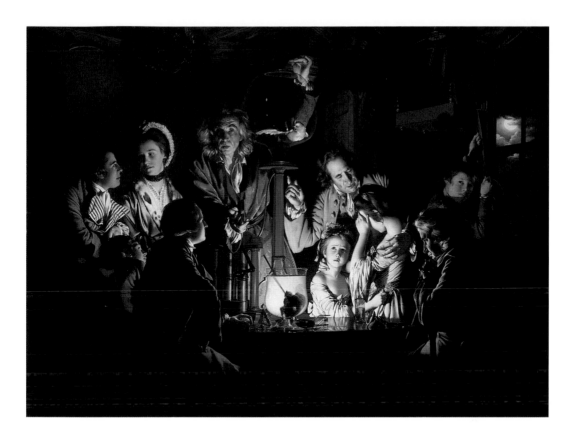

27 *An Experiment on a Bird in the Air Pump*
exhibited 1768
Oil on canvas
182.9 × 243.9
(72 × 96)
National Gallery, London

observations to chart latitude and longitude, and so put the county into a broader cultural frame. Burdett may have helped formulate the subject and content of *The Orrery* to commemorate his patron Earl Ferrers and his cultural esteem in London as well as in Derby.

An Experiment on a Bird in the Air Pump (fig.27), first exhibited in 1768, depicts a more dramatic, even shocking scientific performance. The demonstration of the air pump, something of a parlour trick by scientific showmen, comes at the culmination of a lecture on pneumatics. Unlike demonstrations of mechanics, as shown on the orrery, those of pneumatics were seen not just to describe the world, but to express its active powers, stirring up society as well as nature. The radical Joseph Priestley declared that

> works of fiction resemble those features which contrive to illustrate the principles of philosophy, such as globes and orreries, the use of which extend no further than the views of human ingenuity, whereas real history resembles experiments by the air pump, condensing engine and electrical machine which exhibit the operation of nature, and the God of nature himself. The English hierarchy (if there be anything unsound in its constitution) ... has reason to tremble even at an air pump or electrical machine.

Much of Wright's art has an aerial, pneumatic significance, boys inflating bladders, workmen at the bellows, erupting volcanoes, suffocating

prison cells. At the time the creative process was beginning to be described in pneumatic terms, aspiration and inspiration on one hand, depression and deflation on the other. Wright was a keen player of that most aerial of instruments, the flute, outside by himself in groves and gardens as well as inside in ensembles (with Burdett on violoncello). Wright's periods of creativity contrasted with the pain of long periods of languor when he was too depressed to paint.

The Air Pump has a complex genealogy. The engraving of one of Philip Mercier's fancy pictures entitled *Air* (1756) (fig.28) shows a young woman in a pleasure-ground with a bird perched on her finger; pet birds hovering in the air were conventional emblems of courtship and the accompanying verse refers to a successful one. Wright used this image in a conversation piece of *Mr and Mrs William Chase* (*c.*1762–3) (fig.29). A white bird, a pet parrot, has been taken from its cage and perches on the hand of Mrs Chase. Her husband holds his flute, poised, it seems, from the position of his hands, to play a tune. The room, opening on to a pleasure-ground, is filled with sunlight. Love is in the air.

This cheerful image is inverted by *The Air Pump*. A white bird has been taken from its cage on the right and placed in the air jar from which the air has been expelled. The bird is not the usual expendable sparrow or mouse of such experiments, but rather a luxury pet, a rare white cockatoo, much more expensive than the apparatus which suffocates it. Perhaps it is the pet of the two girls who recoil in horror at the experiment, one of whom cannot bear to watch. The lecturer James Ferguson who did a series of scientific demonstrations in Derby, and on whose drawing of air pump apparatus Wright's seems to be based, recommended substituting 'a machine called the lungs-glass in place of the animal' for 'this Experiment is too shocking to every spectator who has the least degree of humanity'. In Wright's picture, the lecturer's hand is poised at the stopcock, about to release air into the jar and revive the bird, or at least that seems to be the message of the horrified girls' father's comforting gesture. On the table, odd among the various pneumatic instruments, is a liquid-filled glass jar containing the remains of a human skull. This is what the seated old man contemplates, a *memento mori*, a reminder of death. This gives the imminent revival of the bird a spiritual significance. The white bird recalls the

28 Richard Houston after Philip Mercier, *Air* 1756 Mezzotint 35.5 × 25.5 (14 × 10) David Alexander

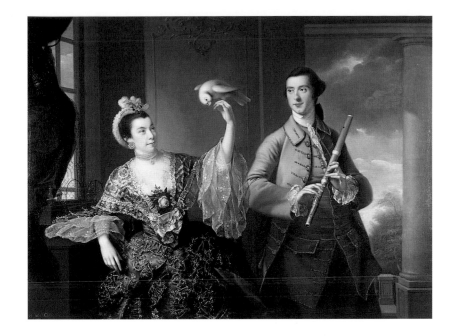

29 *Mr and Mrs William Chase*
*c.*1762–3
Oil on canvas
138.4 × 190.5
(54½ × 75)
Private collection

Paraclete, emblem of the Holy Spirit of Christian theology, but more close-
ly the birds contained in glass retorts in allegories of alchemical transmu-
tation.

Compared to the fatherly philosopher in *The Orrery*, the lecturer in *The
Air Pump* is a more enigmatic, magus-like figure, with one of the most
haunting expressions in eighteenth-century art (fig. 30). Some of the other
figures, the old man looking down, the boy looking up, are modelled on
innovative character studies of 'Heads' (1760–2) by Thomas Frye, a fellow
exhibitor at the Society of Artists and former manager of the Bow porcelain
factory. The boy on the right lowering or raising the bird's cage is, as David
Fraser has shown, based on a figure pointing to a skeleton in Hogarth's
engraving *The Reward of Cruelty*, a scene in an anatomy theatre showing
the dissection of a hanged felon's 'breathless corpse'. The young couple on
the left have been credibly identified as Thomas Coltman and his future
wife Mary. Coltman was a neighbour and friend of Wright in Derby who
purchased two versions of his exhibited Candlelights of a girl reading a
letter and boys fighting over a bladder, also a self-portrait of Wright which
has a study for *The Air Pump* on the reverse. Upon his marriage he rented a
house in Lincolnshire, in the grounds of which Wright's 1771 double por-
trait of the couple is set (fig. 31). The style, and some of the poses, echo
Stubbs's portraits of Midlands patrons but Wright's is a more informal,
more lively picture. Leaning on his wife's left thigh, as she is side-saddled on
her pony, Thomas Coltman awaits his horse to join her for a vigorous,
lung-filling ride in the country. The bright, breezy day, the barking dog, the
blooming foliage, amplify their energy. It is a scene bursting with life and
its physical pleasures, no less than *The Air Pump* an essay in the aerial
imagination.

41

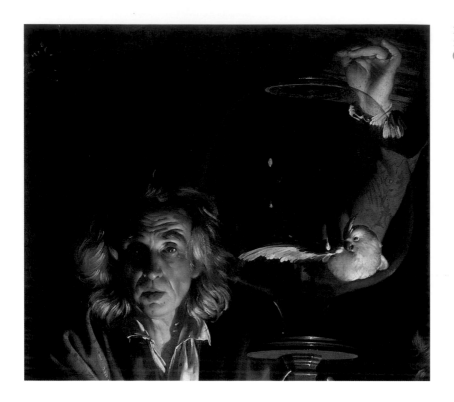

Purchased by Benjamin Bates, the buyer of *Three Persons Viewing the Gladiator*, *The Air Pump* was immediately applauded by critics as an extraordinary picture. The engraving by Valentine Green, published twice in 1769, the second time by London's most entrepreneurial print-seller John Boydell, established it as Wright's masterpiece, extending his reputation throughout Europe. Wright continued to explore chemical power in other contexts and settings, notably *The Alchymist* (fig.16), but Wright's failure to sell this picture or to paint any more such scenes may reflect the fact that the experimental fashion for science was waning. Josiah Wedgwood, whose children were instructed in chemistry by Priestley's assistant Warltire, contemplated a commission on the subject by Wright in 1779, 'Jack standing at a table making fixable air with the glass apparatus &c; & his two brothers accompanying him. Tom jumping up & clapping his hands in joy and surprise at seeing the stream of bubbles ... Joss with the chemical dictionary before him in a thoughtfull mood' (this as a pendant to a picture of his daughters 'Sukey playing upon her harpsicord, with Kitty singing to her ... '), but he decided on a painting by Stubbs instead, a conversation piece of the whole family in the grounds with the children on ponies. He rejected Wright's offer of *The Alchymist* too, for a classical image of technical accomplishment, *The Corinthian Maid* (fig.40).

Addison had found the pleasures of the imagination promoted outdoors by various landscapes from 'stupendous scenes of nature' and 'groves, fields and meadows'. Especially after his return from Italy and Bath in the

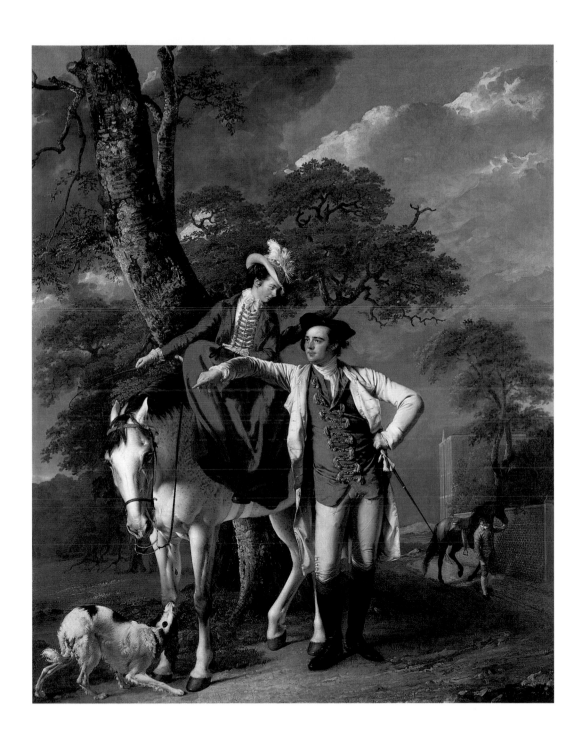

31 *Mr and Mrs Coltman* exhibited 1771. Oil on canvas 127 × 101.6 (50 × 40). National Gallery, London

late 1770s, with a young family and a new taste for landscape, Wright surveyed them in his art.

Some of Wright's circle, notably the Lichfield men Brooke Boothby, Erasmus Darwin and Thomas Day, cultivated their taste for the outdoors through a reading of Rousseau. From the publication of his educational treatise *Emile*, Rousseau exercised a powerful movement of reform in enlightened education. Practical understanding was valued over book learning, tactile over visual knowledge, fresh air and exercise over study in stuffy schoolrooms, discovery through play rather than rote learning and coercion. Darwin 'made it a rule never to contradict his children, but to leave them their own master' and influenced Wright to do likewise when he returned to Derby and moved into a house with a large garden on the edge of the town. His niece reported that Wright encouraged his children to play their ballgames on the gravel walk, and blind man's buff, hide and seek and whipping tops throughout the house. There was not any part of the house they were prohibited from playing in, neither the room where his pictures were arranged, nor in his painting room, at least when he was not working there.

As in Locke's treatise, the knowledge of geography and astronomy in Rousseau's *Emile* was still seen as a framework for further learning but the process by which it should be acquired was radically reformed. It should

32 *Thomas and Joseph Pickford as Children*
c.1777–9
Oil on canvas
147.3 × 122 (58 × 48)
Private collection

33 *Three Children*
of Richard Arkwright
with a Kite 1791
Oil on canvas
195.6 × 152.4
(77 × 60)
Private collection,
on loan to the Tate
Gallery

not start with the acquisition of 'globes, cosmic spheres and maps', but
rather with an accompanied walk in the country at sunset to attend, with
all the senses, to 'the beauty of nature's spectacle'. 'To see it it, one must
feel it.' Through a series of excursions, conversations and his own sketch
maps, the child would come to a clear understanding of his 'habitat' and its
relation to 'the heavens'.

In the 1770s Wright followed the fashion in painting a series of
Rousseauvian portraits of young children. They play in naturalistic land-
scapes, often at sunset, unescorted by adults. The Pickford boys play with
their pet spaniel in a woodland glade (fig. 32), the Arkwright boys with a
kite (fig. 33), the three Wood siblings, two boys and one girl, with a bat
and ball. These are not the stiffly posed, buttoned-up embryonic adults of
earlier child portraiture, but physically real, full-cheeked, sturdy-limbed
children dressed in loose-fitting clothes which encourage them to range

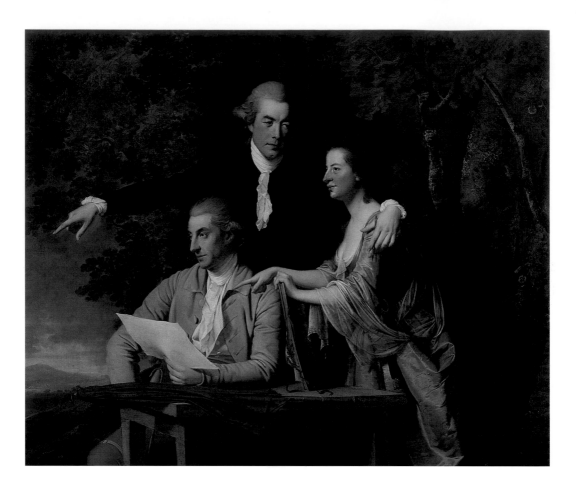

freely. The cavalier-style costume of the boys only serves to underline the carefree atmosphere. The children have a physical presence and intimacy which betokens a close, affectionate family. Wright did some family groups, which are equally Rousseauvian, father, mother and children in close touch with nature and each other.

Wright's conversation piece *The Rev. D'Ewes Coke, his wife Hannah and Daniel Parker Coke MP* (*c.*1781–2) (fig.34) shows nature contemplation in terms of the fashionable accomplishment of landscape drawing. As in *The Gladiator* (fig.21), a drawing is compared with its subject. The subject now is not a statue which only men can appreciate, but the country-side, probably (the table suggests) the polished, picturesquely fashioned countryside of a landscape park. The three subjects are on a sketching excursion, perhaps around the grounds of Brookhill Hall, the Derbyshire estate which the Reverend Coke had recently inherited. The affectionate family bonds between the three figures are evident in their closeness and physical contact, the Reverend Coke with an arm around his wife's shoulder, she leaning against his cousin's shoulder, the three embowered by trees. It is not exactly clear who has done the drawing but the authority is embodied in the men. Hannah Coke is figured, as Shawe-Taylor points

34 *The Rev. D'Ewes Coke, his wife Hannah and Daniel Parker Coke MP*
*c.*1781–2
Oil on canvas
152.4 × 177.8
(60 × 70)
Derby Museum and Art Gallery

out, as a Muse, and given how the colouring of her dress and hair blends her into the woodland bower, a Muse of Nature to accompany and inspire the men. One of the breed of naturalist clergymen (he catalogued wild plants in Derbyshire and etched his drawings), the Reverend Coke, in clerical black, commands the picture. He points to some feature of the landscape with his right hand, while draping his left, which holds his pencil, around the shoulder of his wife, pointing out to her some relation between what they see and what has been drawn.

The masculine strain of nature appreciation and description is evident in the writings of another of Wright's late sitters, the Reverend Thomas Gisborne. In Wright's double portrait of 1786 (fig.35), he sits with his wife (who holds the umbrella) under a tree, probably near his house in Needwood Forest, holding his portfolio and pointing to a scene he is drawing. In his poem *Walks in a Forest* (1796) Gisborne maintained that nature did not inspire leisure and equality, rather the opposite, a divinely ordained social order in which men and women, young and old, rich and poor knew their place. Britain was now at war with France, pastoral ease was morally suspect. Among 'those moral truths, which the contemplation of God in the natural world suggests', noted Gisborne, was that 'Britannia's freeborn offspring' should not 'sport and flutter' like the birds. 'Teach them the harder, nobler task decreed | To prove the sons of Adam.'

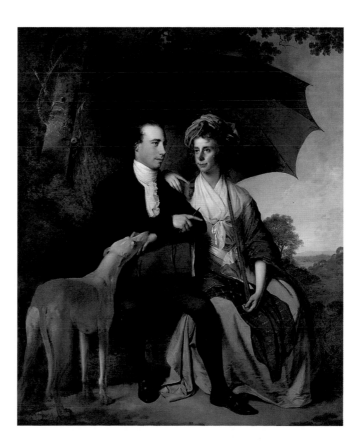

35 *Rev. Thomas Gisborne and his wife Mary* 1786
Oil on canvas
185.5 × 152.5 (73 × 60)
Yale Center for British Art,
Paul Mellon Collection

3

MECHANIC GENIUS

Immediately after Wright's death in 1797, his brother Richard sent some biographical details to a former pupil, William Tate:

> At an early time in life he shared a great propensity to knowledge in several mechanical branches, and being of an active mind, would frequently spend his vacant time from school in going to different shops to see the men work & when he returned home, would imitate their works & compleat them in a masterly manner such as joiners goods, chests of drawers, clocks, spinning wheels, guns &c ... his genius afterwards turned to Drawing and Painting.

In his niece Hannah's account we read that Wright's 'mechanical genius' was deployed in a variety of ways connected to his art, in constructing a 'raree-show', a miniature theatre with glass transparencies of Italian views with which he later entertained his family, and a large folding screen device in his painting room, 'an apparatus for painting candlight pieces and effects of firelight'.

These accounts connect Wright strongly to the Midlands culture of technical accomplishment and inventiveness, represented by his nationally renowned patrons Wedgwood, Arkwright, Darwin and Whitehurst, as well as a host of instrument-makers, architects, engineers and manufacturers known mainly in the region. It was a culture preoccupied with the mechanics of production and reproduction, in a variety of processes from pottery to printing. It was clearly allied to commercial progress and money-making, but did not necessarily entail deskilling or slavish imitation; properly developed and controlled, perhaps by legislation, the mechanical arts offered a model of creativity in art of all kinds. The culture was not confined to provincial England. A leading forum in London was the Society of Arts, which offered premiums for technical improvements in a variety of processes and products which benefited the economy, including etching, cameo-cutting, tree planting, weaving, spinning, ploughing, painting and surveying. In the Society's premises on the Strand oil-paintings and watercolours were displayed alongside maps and mechanical models. Awarded a premium by the Society for his Map of Derbyshire, Peter Perez Burdett also exhibited aquatints at the Society. When Burdett moved to Liverpool in 1769 he founded a Society of Arts there on the same model, exhibiting both fine and applied art.

In a period when a variety of professions were keen to establish their status and identity, it is perhaps not surprising that professional artists should set up their own society. Founded in 1769, the Royal Academy

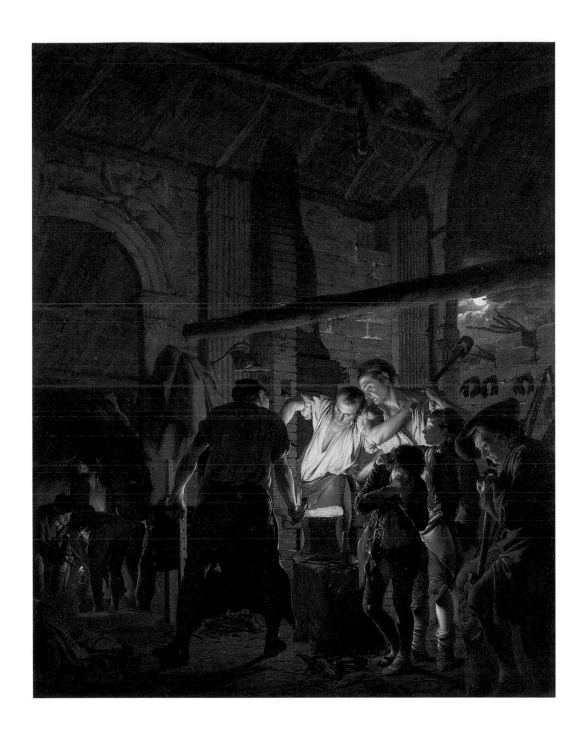

36 *A Blacksmith's Shop* 1771. Oil on canvas 128.3 × 104 (50½ × 41)
Yale Center for British Art, Paul Mellon Collection

offered not only specialist training and exhibition space but, through the lectures of its founding president, Sir Joshua Reynolds, a redefinition of art, setting painting and drawing on a higher path than the mechanical arts and commercial utility and appealing to abstract concepts of beauty. Artists were urged to set their sights above everyday genre scenes, or topographical or scenic landscapes, and aspire to the high seriousness and grand style of history painting. Few practising painters actually followed this programme to the letter, even when exhibiting at the Royal Academy, but Wright seems to have made a point of challenging it. Wright exhibited in London at the Society of Artists which included engravers as well as painters among its members. When the Society foundered, he exhibited at the Royal Academy but famously quarrelled with the institution and resigned his membership. He sought a platform elsewhere, at the reformed Society of Arts in Liverpool and in 1785, in one of the first exhibitions of its kind, with a one-man show in Covent Garden, London.

In exploring the theme of manufacture in Wright's art, it becomes evident that while some of the pictures depict machines, metalworking and mass production, they cannot simply be classed as Midlands art or packaged as part of the Industrial Revolution. In his scenes Wright depicts a number of themes which are found in agrarian art of the period; the relation of industry and idleness, labour and supervision, mythical allusion and workaday actuality. Some of Wright's subjects, notably blacksmithing, were as traditional as any of the agricultural tasks in rural art and, of course, fully integrated into an agrarian economy. On the other hand, Wright's representations of manufacture are not simply conventional paintings of work. They explore a series of overlapping issues about mechanisation: the relations of technology and toil, masculine and feminine tasks, commercial intelligence and freedom of information. Moreover, they address the very relation of the fine and mechanical arts which framed views of painting as a profession.

From 1771 to 1773 Wright exhibited at the Society of Arts a remarkable series of five paintings showing night scenes of iron forging. They were quickly sold to prestigious patrons, in two cases reserved for them. Lord Melbourne, who owned a good picture collection at his Hertfordshire country house as well as productive iron forges at his Derbyshire seat, purchased one version of *A Blacksmith's Shop* straight off the easel (fig. 36). 'It is worth your while when you go to Derby to see the picture he is painting for me,' he told his agent, 'It is thought to be the Best ever painted in the Country.' Burdett acted as agent for the sale of *An Iron Forge viewed from without* (fig. 39) to Catherine the Great, Empress of Russia, who was building a large collection of Midlands wares, including a Wedgwood service (exhibited to spectacular effect in London) and a Whitehurst designed, Matthew Boulton manufactured ormulu clock. Two paintings of blacksmiths' shops and one of the iron forge were immediately engraved and advertised for sale.

In these pictures of forging scenes Wright takes a staple subject of European genre art, technical illustration and topographical engraving and works it up into a sublime spectacle, with the heroic grandeur of

history painting. Workmen, their women and children strike classical poses, brilliantly illuminated by the white-hot metal on the anvil. It is as if the very process of ironworking and refining, when respectfully attended to by worker and spectator, offers a model of creativity and cultural refinement.

The virtues of manufacture and the mechanical arts were promoted in a number of commercial, moral and spiritual writings at this time. Political economists located the nation's wealth and well-being in the figure of the skilled and sturdy artisan. Moralists looked to the mechanical arts as a model of industriousness in all spheres, the artificer as a role model for the philosopher, his practical work a paradigm for speculative thought. Spectacular industrial sites, notably Coalbrookdale, attracted tourists and were represented in contemporary views and descriptions as suitable sites for a range of contemplative moods and forms of observation. Wright mobilises explicitly mythological artistic traditions, notably images of Vulcan at his forge, but also paintings of the Nativity, the luminous ingot on the anvil in place of the radiant child in the manger. The setting, a chapel-like structure with an angel carved over the doorway, reinforces the allusion. In this reworking of Christian and classical myth, Wright draws again on a tradition of speculative alchemy. At the time of these pictures this was current not just in the rituals of London Masonic lodges of Wright's middle-class circle, but in the worship of industrial workers in the chapels and open-air meetings of the mystical Swedenborgian wing of Methodism which flourished in the Midlands and North West.

37 Gabriel Metsu,
Interior of a Smithy
*c.*1657
Oil on canvas
65.4 × 73.3
(25¾ × 28⅞)
National Gallery,
London

38 *An Iron Forge*
1772
Oil on canvas
121.9 × 132.1
(48 × 52)
Tate Gallery

In some notes for *A Blacksmith's Shop* Wright set out the occasion for the scene, a traveller meeting with an accident at night and needing new horseshoes to be forged. The traveller is a person of some importance with his servant and portmanteau but, in contrast to some earlier Dutch pictures on this theme (fig. 37), he is relegated to the shadowy margins of the picture. Wright's smiths occupy centre stage, working strongly, skilfully and urgently, industrious but not submissively so. Their masculine power is highlighted by the figures who surround them. In one version, as in Wright's notes, a young man, 'an idle fellow', looks nonchalantly past, hands in pockets, and a younger boy (his brother?) recoils from the heat. In the other a young woman twists away from the hot metal, showing an erotically bared shoulder, playing Venus to Vulcan, and confirming the blacksmith's virile reputation in English folklore.

The pictures of iron forges show a larger-scale, more mechanised scene of manufacture (fig. 38). A man with his back to us holds a large bar of glowing metal on the anvil to be shaped by a tilt-hammer into an ingot of cast iron. The mechanism, a revolving drum turned by a water-wheel, is clearly displayed; in the view from without we see the mill-stream, the source of the power. The equipment is not innovative or new to painting – a picture of Vulcan's forge by Jan Brueghel shows a tilt-hammer forging weapons of war – but is also clearly of its moment. There were a number of such forges in the ironworking regions of Derbyshire and Wright based this one, with its great beam reinforcing what seems to be a former barn, on

an earlier drawing which appears to have been made on site. Such forges were one stage of iron manufacture in a series of sites throughout the Midlands which took in mines, furnaces, slitting and rolling mills and metal manufactories, from Birmingham to Sheffield.

Wright's forge scenes are evidently more highly capitalist than his smithy scenes with more of a division of labour. In *An Iron Forge* (1772) (fig.38) one man takes centre stage, his powerful arms and shoulders echoing the articulation of the great hammer and beam. His muscularity and leather apron show that he works at the forge, but his fine waistcoat and pose suggest that he is (in contrast to the man who positions the ingot) more than a labourer. He is figured as a small master supervising his man and complacently admiring both the source of his wealth and the elegantly dressed and carefully posed wife and family it supports. The social dynamics shift in *An Iron Forge viewed from without* (1773) (fig.39). A more gentlemanly figure takes the central position. He may be the owner of the forge, the family man his manager. He is dressed in the style of Wright's portrait of a prominent Derbyshire ironmaster and landowner Charles Hurt, whose family dominated the mineral and metal industry of the Derwent above Derby. The wooded cliffs locate the scene in this stretch of country and show the raw materials of wood and limestone for smelting which gentleman industrialists such as the Hurts were keen to control.

If in the forge scenes Wright raised the cultural register of genre and subject to epic proportions, in a commission for Josiah Wedgwood he scaled down history painting to make it a vehicle for the virtues of the mechanic arts as well as an accessible and acceptable subject for Wedgwood's female market of polite consumers. *The Corinthian Maid* (c.1782–5) (fig.40) and

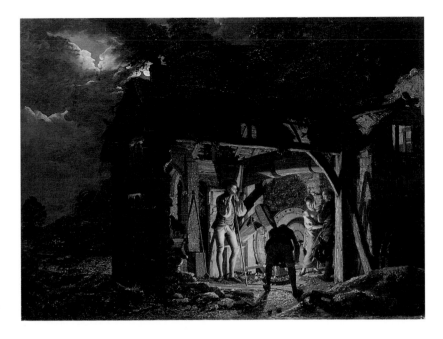

39 *An Iron Forge viewed from without*
1773
Oil on canvas
105 × 140
(41⅜ × 55⅛)
Hermitage Museum,
St Petersburg

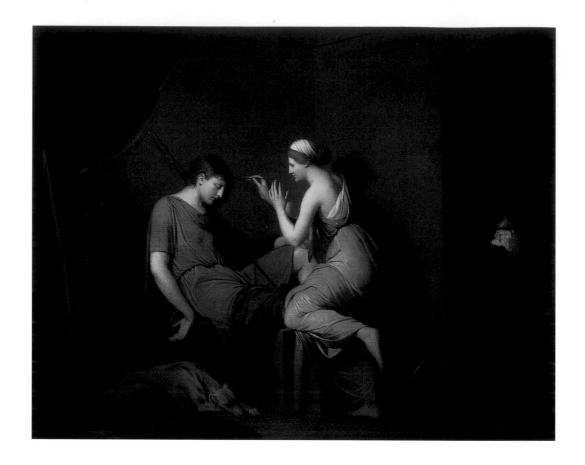

Penelope Unravelling her Web by Lamp-Light (fig.41) illustrate episodes from classical mythology with manufacturing subject-matter. The Corinthian maid, a potter's daughter, was a particularly choice subject for Wedgwood. Legend had it that she invented the art of portraiture by tracing the outline of her sleeping lover on a wall before he left the country, an image her father fixed for her by filling in the outline with clay and baking it in his kiln. The immediate inspiration for Wright's picture, and the occasion for proposing the subject to Wedgwood, is the legend's retelling in his friend William Hayley's poem *An Essay on Painting* (1778). This essay, as Ann Bermingham points out, invents a myth of origin for graphic as well as plastic art, and dignifies drawing as a female accomplishment.

> The line she trac'd with fond precision true,
> And, drawing, doated on the form she drew ...
> Thus from the power, inspiring LOVE, we trace
> The modell'd image, and the pencil'd face!

Wright's composition took shape over a number of years through negotiations with his client. Wedgwood suggested the potter's kiln appear,

40 *The Corinthian Maid c.*1782–5
Oil on canvas
106.3 × 130.8
(42 × 51½)
National Gallery of Art, Washington, Paul Mellon Collection

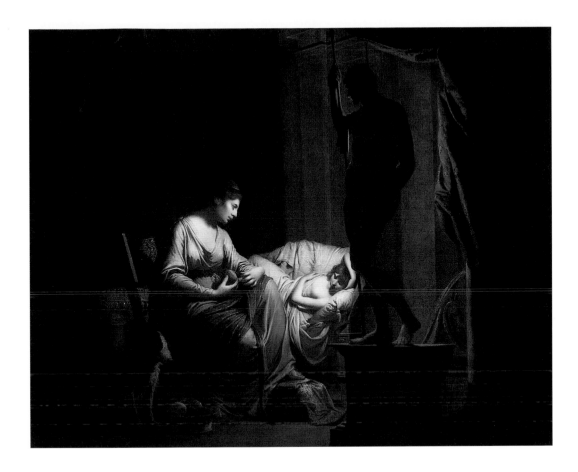

41 *Penelope Unravelling her Web by Lamp-Light* exhibited 1785 Oil on canvas 101.6 × 127 (40 × 50) The J. Paul Getty Museum, Los Angeles

but not a 'Room filled with elegant Earthen vessels', wondering, somewhat literally, how 'our Vases ... could be supposed to exist in the infancy of the potter's art'. When Wedgwood escorted some ladies to the Wrights' house to see the picture on the easel, they were shocked at the immodesty of the Maid. They objected, said Wright, to 'the division of the posteriors appearing too plain through the drapery and its sticking so close, tho' truly Grecian, as you justly observe', and he complied by casting 'further drapery [to] conceal the Nudity'. The figure of the sleeping lover is taken from an ancient bas-relief Wright sketched in Rome. Together they make a fashionable neo-classical couple, in a design fit for a decorative relief on a Wedgwood pot.

Wright painted *Penelope Unravelling her Web* (fig.41) as a companion to *The Corinthian Maid* (fig.40). Penelope is another figure of female fidelity, the wife of Ulysses who waited patiently for her husband to return from his voyage, despite the cajoling of various princely suitors who tried to persuade her that he must have died. She tells them she cannot remarry until she has woven a shroud for Ulysses' father, which she does all day,

and then unravels at night. The subject was suggested by Hayley, who also came forward with various ideas for Wright's picture, including Penelope watching over the sick child as she rewound the yarn. When Wright exhibited the painting at his one-man show in 1785 he appended a passage from Pope's translation of the *Odyssey*:

> The work she ply'd; but studious of delay,
> By night reversed the labours of the day.

Signifying the labours of the day caused Wright some concern. A polite female spectator, accomplished in making samplers, might identify with Penelope and a ball of yarn, but scarcely with the work of weaving carried on by hundreds of poor women and men. 'Ovid I think says nothing more than she used to work at her loom', Wright wrote to Hayley, '& I am at a loss how to construct the frame, as all vulgar ideas shou'd be kept out of such a subject & which the common Weavers Loom wou'd naturally excite in every spectator but if necessary to be introduced, it may be partly concealed by drapery.' In the painting the draped loom is half hidden behind a pillar. The statue of naked Ulysses, even in shadow, posed problems too, being 'unfit' Wright was told 'for the chaste eyes of our English ladies'. Objecting to further drapery, Wright came up with an accurate expedient, the figure of Ulysses holding the bow and arrows he was famed for, the quiver crossing 'the bottom of his belly & render[ing] him perfectly decent to the chastest eye'.

Wright's portrait of Richard Arkwright (fig.42) poses the cotton manufacturer with a model of the spinning frame he patented twenty years before and which had proved to be the source of his fortune. It was not only the key component of his own cotton mills in the Midlands and North West but licensed at high prices to other large-scale manufacturers with at least a thousand spindles. Arkwright's patent was continually disputed and infringed, and legally challenged at two celebrated and expensive trials. Wedgwood thought Arkwright had overreached himself but agreed, along with Darwin, Boulton and some of Arkwright's workmen, to testify for his defence. Arkwright's attorney introduced his client as 'one of the most ingenious mechanics this or any other country has produced'. 'It is well known', he continued 'that all the most useful discoveries that have been made in every branch of arts and manufactures, have not been made by speculative philosophers in their closets; but by ingenious mechanics, conversant in the practices in use in their time, and practically acquainted with the subject matter of those discoveries.' The defence argued that the patent protected Britain's interests as well as Arkwright's and after losing the case Arkwright threatened to publish all technical details of the machine 'that it might be known to foreign nations as well as our own'; he was perhaps dissuaded by Wedgwood's encouragement to adapt it for wool spinning. Commissioned before the final trial, Wright completed Arkwright's portrait after it, showing him as a patriotic John Bull figure. Wright depicts the machine with explanatory precision (fig.43); indeed it recalls the models which were exhibits at the trials. Arkwright sits

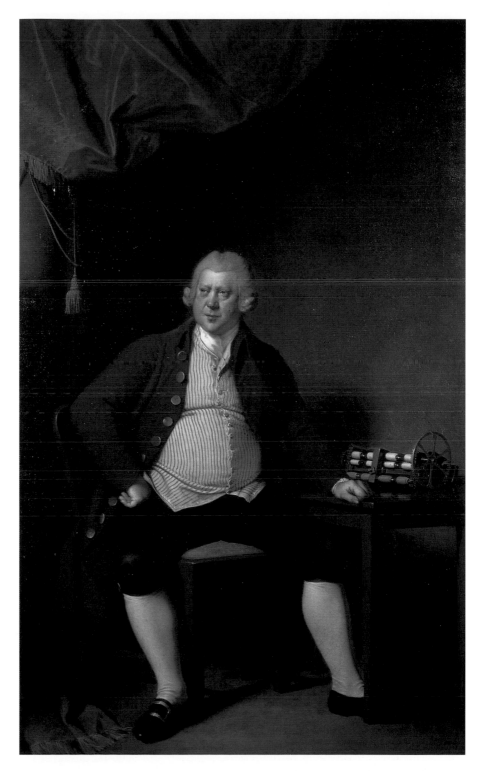

42 *Sir Richard Arkwright* 1789–90. Oil on canvas 241.3 × 152.4 (95 × 60)
Derby Museum and Art Gallery

proudly and defiantly by the invention he still claimed as his own. It was then more than a prop, but signified the sitter's identity, even the very idea of portraiture the painting represents. Wright painted Arkwright ingeniously but plainly; it was, so to speak, a patent likeness.

The painting *Arkwright's Cotton Mills by Night* (*c.*1782–3) (fig.44) alludes to the spinning frame, for the terms of the patent had incorporated the machine within the factory system. The mechanics Arkwright employed to design, make and maintain all his machinery were sworn to secrecy in their indentures. In Wright's painting we see nothing of the technology of production, nor the women and children working at the machines, only the spectacle of the mills at Cromford lit up for the night shift under one of Wright's full moons. By the 1780s many manufacturers, including Wedgwood and Boulton, were fearful of industrial espionage and had become cautious about letting visitors look inside their factories. Making a public attraction of the outside, through ornamental façades, landscaping and illumination, satisfied tourist tastes while protecting their civic responsibility for the processes within. The rosy glow on the outside of the mills in Wright's painting may allude to their illumination on festive, patriotic occasions. They were images of power. Arkwright's mills reminded more than one visitor of the only structures to rival them in size and power: battleships. 'These cotton-mills, seven stories high and fill'd with inhabitants remind me of a first rate man of war', noted the aristocratic tourist John Byng, 'and when they are lighted up on a dark night look most luminously beautiful.'

Factories were commonplace subjects in illustrative art and prints (Arkwright's mills were depicted in a number of media, including a dish of Derby porcelain decorated by Zachariah Boreman), and famous buildings, such as St Paul's Cathedral, lit from within, featured in peep-show transparency prints. Wright took the initiative to work up the subject and spectacle into an exhibition-sized oil. *Arkwright's Cotton Mills by Night* was not sold to Arkwright, but to Daniel Parker Coke, MP for Derby, then Nottingham. Coke was a staunch defender of the factory system and in the portrait with his cousin the Reverend D'Ewes Coke and his wife (fig.34), Wright depicts him as a keen judge of landscape art.

Many of Wright's themes on the mechanical arts, and some of his imagery, were grist to what Erasmus Darwin called 'the Rosicrucian machinery' (that is, the Masonic theory) of his long poem *The Botanic Garden*. In Vulcan's forge, Venus

> Admir'd their sinewy arms, and shoulders bare,
> And ponderous hammers lifted high in air.

In an ironworks,

> Quick whirls the wheel, the ponderous hammer falls,
> Loud anvils ring amid the trembling walls,
> Strokes follow strokes; the sparkling ingot shines,
> Flows the red slag, the lengthening bar refines.

43 *Sir Richard Arkwright*
1789–90,
detail of spinning frame
(see fig.42)

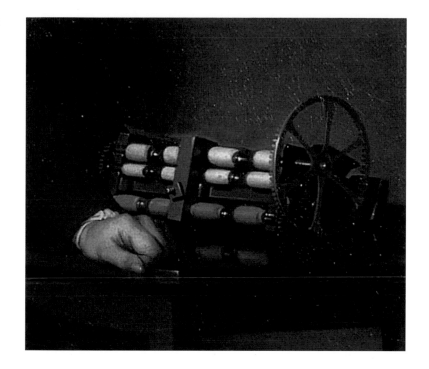

44 *Arkwright's Cotton*
Mills by Night c.1782–3
Oil on canvas
99.7 × 125.7 ($39\frac{1}{4}$ × $49\frac{1}{2}$)
Private collection

45
P.J. de Loutherbourg,
*Coalbrookdale by
Night* 1801
Oil on canvas
67.9 × 106.7
($26\frac{3}{4}$ × 42)
Science Museum,
London

At Etruria,

> Glides the quick wheel, the plastic clay expands,
> Nerved with fine touch, thy fingers (as it turns)
> Mark the nice bounds of vases, ewers and urns;
> Round each fair form in lines immortal trace
> Uncopied Beauty, and ideal Grace.

At Arkwright's mills,

> With quicken'd pace *successive rollers* move,
> And these retain, and those extend the *rove*;
> Then fly the spoles, the rapid axles glow,
> And slowly circumvolves the labouring wheel below.

The most dramatic reworking of Wright's nocturnes of manufacture is Loutherbourg's *Coalbrookdale by Night* (1801) (fig.45). This painting portrays iron furnaces at night under a full moon in an infernal, apocalyptic scene. Produced when the iron industry was working at full blast to supply weapons for war with France, and exhibited at the Royal Academy when scenes of work were established as pictorial subjects, this is a highly patriotic and explicitly martial scene. It is also a Masonic one, deploying the alchemical imagery and theatrical effects Loutherbourg used in his painted scenes to accompany the Egyptian Rite of Freemasonry. Darwin and Loutherbourg did not merely copy Wright, indeed Wright seems also to have drawn on their work; rather they were each part of a culture which was eager to portray the arts of machinery and manufacture and speculate on the various traditions and transformations they entailed.

4

EXCURSIONS INTO LANDSCAPE

From around 1770 the settings of Wright's subjects become more prominent, more expressive as scenery. Wright proved his proficiency in painting scenic settings of many kinds and in many styles to amplify the mood and meaning of the subjects, whether portraits, genre or literary scenes. During his sojourn in Italy and after his return, Wright's attention to scenery increased, and he began to paint landscapes proper, in which figures and action, although evident and significant, were subordinate to the prospect of the land. By the end of his life he was drawn to landscape above any other genre. 'I have just prepared a canvas the size of Tate's Moonlight for an evening effect and another view on the river Tay at Dunkeld which if care & study will accomplish it I intend to be the best picture I ever painted,' he declared in 1792; 'I know how it is, tho' I am engaged in portraits & made a compleat dead colour of a half length yesterday, I find myself stealing off, getting to Landscapes.'

Wright's excursions into landscape follow a well-trodden trail in English art of the time. He was one of a number of painters who sought to raise the status of landscape as genre, drawing on a range of knowledge to depict relations of land and life in particular places, using recognisably English scenes to survey general moral and religious themes, exploring the intersection of the epic and the everyday. Wright consulted the standard guidebooks to landscape painting, by Alexander Cozens and William Gilpin. He was influenced by, and in turn shaped, the poetry of landscape. He followed the trail of tourists and artists visiting the classic ground of Italy, looking and painting in the style of Claude Lorrain and Salvator Rosa. He also took in the fashionable scenery of the Lake District, and, as with his trip to Italy, regretted that it had taken him so long to get there. Wright depicted the sites and scenery of Derbyshire's Derwent valley, as other painters did along other English river valleys, the Thames and Wye, the various Stours and Avons. Wright's landscapes stand out for their spectacle and drama, for the variety of real and imaginary places he painted, and the range of knowledge about the landscape he deployed, from picturesque tourism to geological speculation. Although his landscapes are not so well-regarded now, towards the end of his career Wright was highly esteemed as a landscapist, more so by some critics than as a portrait or history painter, and he made a good living from it.

Derbyshire had proved one of the first painting grounds for British landscape art. Prints of the Peak District in the 1740s after paintings by the Derby artist Thomas Smith, showing sublime crags and magnificent caves, and describing the mineral wealth of the region, promoted a taste for

British scenery. In 1756
Alexander Cozens, one of the first
British artists to visit Italy, did
some scenes of Matlock Tor in
the more polished style of the
classical landscape painter
Claude Lorrain.

Early in his career, in portraits
and genre scenes, Wright
introduced craggy, identifiably
Derbyshire, landforms. His first
pure landscape in oils, entitled
simply *A Landscape*, was
exhibited at the Society of Artists
in 1772, and is probably the
painting now called *Rocks with*

Waterfall (*c.*1772) (fig.46). This is a dramatic composition with forceful
brushwork and careful rendering of the texture and shape of buckled rock
strata, twisted and clinging trees and rushing water. It appears a familiar
piece of Derbyshire scenery until we spot three tiny banditti in the fore-
ground, figures which put the cliff into scale as a massive rock-face and
signify the sublime style of Salvator Rosa.

46 *Rocks with
Waterfall c.*1772
Oil on canvas
80.7 × 109.2
(31¼ × 43)
Private collection

Wright's landscapes reflect the influence of Alexander Cozens. As well as
depicting Derbyshire, Cozens was the author of treatises on drawing land-
scape which corresponded with the inventive culture of Wright's
circle. Cozens maintained that too much time was spent slavishly imitating
both the works of other artists, and the landscapes of nature; he proposed
various methods or 'systems' as he called them, to liberate the creative
imagination and 'facilitate the inventing of landscapes'. These included
making semi-random blots and working up landscape compositions
from their novel and suggestive configurations (fig.47). The spirit as
well as the letter of such exercises would equip the artist to handle
with originality the various demands of painting particular landscapes,

47 *Landscape Study Developed
from a Blot ?c.*1770
Pencil, brush and black ink wash
on paper
27 × 38.7 (10⅝ × 15¼)
Derby Museum and Art Gallery

together with the actual look of the land and the style of other authoritative artists.

Wright himself left England for Italy in 1773, at the relatively advanced age for a professional artist of 39. Having just married, he probably wanted to have a foreign honeymoon, as well as to find new subjects and a new market for his art to support the prospect of family life. He departed Derby in October and reached Rome the following February. Letters home and sketches on the spot make plain the profound effect upon him of Italy, its antiquities and natural scenery, but also some of its modern attractions. Rome, he told his sister Nancy, was 'a noble place to study in, and if so many years had not passed over my head I should be tempted to stay longer'. The Italian landscape was 'beautiful & uncommon, with an atmosphere so pure & clear that objects twenty miles distant seem not half the way'. Like scores of other artists in Rome Wright drew the 'classic ground', the ruined archways, hilltop villas, castles and lakes, with an attention to the texture of stone and foliage and the brilliant light (fig.48). He also drew one of the civic and religious spectacles of contemporary Rome which lit up the old city, the Girandola, a huge firework display staged twice a year, at Easter and during the feast of St Peter and St Paul in June.

The Girandola took its name from the firing of rockets from a huge revolving wheel mounted on the roof of the Castel Sant'Angelo. The spectacle was a major tourist attraction, and a subject for prints and peepshow transparencies. Wright took the opportunity which no other British artist grasped, of making it a subject for a series of large, exhibition-sized oil-paintings (fig.49). Wright shows the Girandola for what it was, a massive Roman candle sending up colourful smoke and flame with the whizzing rockets, and how, from different vantage points, it illuminated various buildings and monuments, notably the lantern-lit dome of St Peter's, and enhanced Rome's civic splendour.

Wright followed the trail of the Grand Tour to Naples, and a local landscape dominated by Mount Vesuvius. He observed the activity of the volcano itself and the excavations of the cities of Pompeii and Herculaneum overwhelmed by the lava of past eruptions.

48 *Italian Landscape with Buildings*
1774–5
Pen and ink and ink washes over
pencil on paper
22.5 × 37.2 (8⅞ × 14⅝)
Derby Museum and Art Gallery

Wright's views of Vesuvius (he painted thirty) proved to be a lucrative line (fig. 50). The volcano itself, one of the most popular sights on tours of Italy, was a frequent subject of painting and all manner of illustration. There was a large and enthusiastic market for volcanoes in eighteenth-century Europe, an audience keen to consume the latest news of eruptions and speculations on their geological origins and archaeological effects. The British Ambassador to the Court of Naples, the connoisseur Sir William Hamilton, investigated the activity of Vesuvius during his long period of office, observing the activity of the volcano with a battery of instruments, collecting specimens of lava and ash, and issuing various publications of his findings. Hamilton promoted the role of volcanoes as a major creative force in shaping the earth. It was Wright's friend John Whitehurst who established the role of volcanic force when he discovered that specimens of Derbyshire toadstone were like ash from Vesuvius, arguing for 'subterraneaous fire' as the main agent of the earth's transformation.

'When you see Whitehurst', Wright wrote to his brother, 'tell him I wished for his company when on Mount Vesuvius, his thoughts would have centr'd in the bowels of the mountain, mine skimmed over the surface only; there was a considerable eruption at the time, of which I am going to make a picture. 'Tis the most wonderful sight in nature.' Here Wright acknowledges an issue which had concerned Hamilton when he commissioned Peter Fabris to illustrate his geological observations, to make a pictorial tradition concerned with spectacular effects portray the profundity of the volcano's structure and origins. Some of Wright's versions of Vesuvius convey an impression of the volcano's inner power (the jet from one cone recalls the jet of phosphorus from the alembic in *The Alchymist* (fig. 16)) but geology is only one of a number of concerns which inform

49 *Firework Display at the Castel Sant'Angelo*
*c.*1775
Oil on canvas
42.5 × 71.1
(16¼ × 28)
Birmingham Art Gallery

Wright's views of the volcano and its surroundings. Pictorial effect was primary. Three of Wright's versions of the Girandola were painted as companions to views of Vesuvius erupting. 'The one is the greatest effect of Nature,' he wrote, 'the other of Art.' Wright depicted various rituals around the mountain, including the procession of the ancient rite of St Gennaro, thought to ward off the volcano's destructive effects. Another may be the burial of the Roman author Pliny, killed in the great eruption which buried Pompeii when he scaled the crater to examine the source of its power. A daylight view of Mount Etna on Sicily (fig.51), based on other artists' views as Wright never visited it, was painted as a companion to a nocturne of Vesuvius. The town, Catania, shines brightly behind a foreground of black, congealed lava, complementing the settlements and vineyards beneath Vesuvius. Volcanoes, Wright shows, are many things – primordial events, firework displays, historical landmarks, foci of religious ritual – complex cultural landscapes with many layers of meanings.

Few of Wright's Italian paintings were completed in Italy; most were worked up for exhibition and sale when he returned to England in 1775, from drawings or gouache sketches he made on the spot and later developed from a variety of other visual and literary sources. The landforms and light of Wright's Italian landscapes are a recurring motif in his art and shape various other subjects. Wright referred constantly to highly detailed drawings of a watery cave around the Gulf of Salerno, as a scene of dramatic light effects and as a setting for theatrical action, the plotting

50 *Vesuvius in Eruption, with a View over the Islands in the Bay of Naples* *c.*1776–80 Oil on canvas 122 × 176.4 (48 × 69½) Tate Gallery

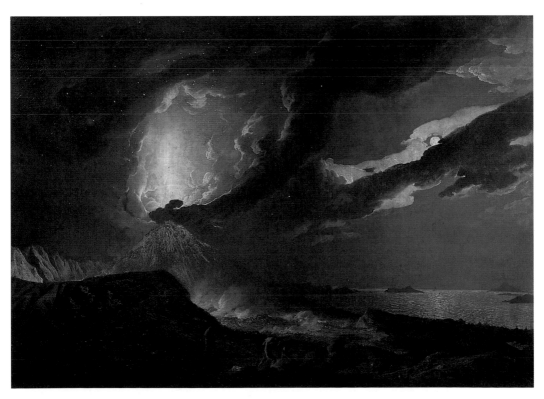

51 *A View of Mount Etna and a Nearby Town* *c.*1775
Oil on canvas
66 × 88.5
(26 × 34⅞)
Tate Gallery

of banditti and of the wailing figure of Julia, adulterous daughter of the Emperor Augustus, who was banished from Rome to the coast of Naples, and perhaps doomed by a rising tide (fig.53).

When Wright returned to Derby in 1777, after an unsuccessful stint in Bath, his native landscape rose in popularity and cultural esteem. It was represented in a number of genres, scenic pantomime, geological writing and picturesque tourism, which Wright deployed in his own paintings of the region.

In 1779 the Drury Lane Theatre staged the first run of a spectacular scenic pantomime, *The Wonders of Derbyshire*, designed by Philip de Loutherbourg (fig.52). Based on drawings he had made on a tour the previous summer and on local fables of landscape origin told during scenic tours, Loutherbourg created twenty-one stage sets with dramatic lighting and sound, linked by a magical storyline, starting with Matlock Tor and going on to various sites in the tourist itinerary of the Peak District, lead mines, Dovedale and the caverns of Castleton (complete with the huts of rope-spinners). The 'Genius of the Peak' rises from his 'haunts profound'

52
P.J. Loutherbourg, 'Cave scene' set design for *The Wonders of Derbyshire* 1778-9
Watercolour
Victoria and Albert Museum

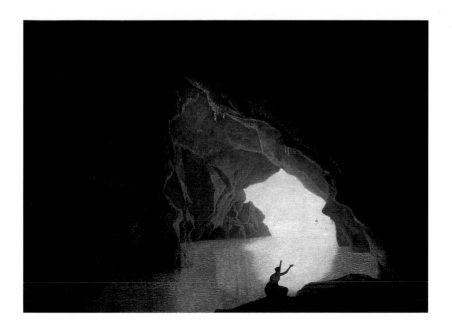

53 *A Grotto in the Gulf of Salerno, with the figure of Julia, banished from Rome* exhibited 1780
Oil on canvas
114.3 × 175.3
(45 × 69)
Private collection

below Matlock Tor to endow miners with supernatural gifts to prospect for minerals. In a spectacular transformation scene, he conjures a brilliant palace and gardens from a gloomy cave. The main drop before the curtains went up, showing a panorama of the Peak District's mountains and waterfalls, became a trademark of the theatre for many seasons after.

In 1778 Whitehurst, now with an official appointment at the Mint in recognition of his scientific work so far, published his *Inquiry into the Original State and Formation of the Earth* to great acclaim, earning election to the Royal Society the following year. While reports of earthquakes and volcanoes were taken from around the world, the main field observations are from outcrops, mines and boreholes in Derbyshire, including the keystone of Whitehurst's theory, the illustrated section of strata at Matlock Tor (fig.54) which shows volcanic toadstone interleaved with limestone, and below the bed of the Derwent, a rubble-filled vent reaching down, so the theory presumed, into the subterranean sea of fire. 'The book of nature

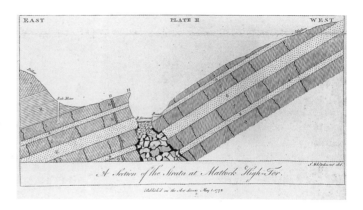

54 After John Whitehurst. *A Section of the Strata at Matlock High Tor* Engraving in *An Inquiry into the Original State and Formation of the Earth* 1778

55
John Whitehurst FRS
c.1782–3
Oil on canvas
92.1 × 71.1
(36¼ × 28)
Private collection

is open to all men', wrote Whitehurst, 'and perhaps no part of the world more so than Derbyshire.' In his portrait, Wright shows Whitehurst with his drawing of the section at Matlock Tor, and through the window a smoking volcano (fig.55).

William Gilpin's appraisal of Derbyshire in a tour of 1772 circulated widely in manuscript before its publication as *Observations relative to Picturesque Beauty* (1785). Travelling from the Lake District, where he found the beauty of the scenery blended with the 'pleasing simplicity and manners' of the people, Gilpin recoiled from the bleaker northern stretches of the Peak District, the precipices, caverns and mines, the 'wild and wretched' people: 'I never found any picturesque beauty in the interior regions of the earth.' But he warmed to the scenery further south in the valleys of the Derwent and Dove, where the landscape was more civilised and composed. The vale of Matlock was 'a romantic and most delightful scene, in which the ideas of sublimity and beauty are blended in a high

56 *Matlock Tor, Moonlight*
c.1777-80
Oil on canvas
63.5 × 76.2
(25 × 30)
Yale Center for British Art, Paul Mellon Collection

57 *Landscape with Figures and a Tilted Cart: Matlock High Tor in the Distance*
c.1790
Oil on canvas
101.6 × 127
(40 × 50)
Southampton City Art Gallery

degree'. Matlock Tor was the 'most magnificent rock, decorated with wood, and stained with various hues, yellow, green, and grey ... It is impossible to view such scenes as these without feeling the imagination take fire.'

Matlock Tor, a landmark of both picturesque admiration and philosophical speculation, became a key subject of Wright's art, studied under various conditions, from various vantage points. There are serene views in sunlight, in the style of Claude Lorrain, echoing Wright's Italian scenes of the cliff-fringed crater lakes of Albano and Nemi, as well as haunting scenes under moonlight (fig. 56). In some daylight scenes the Tor glows brilliantly like a torch, illuminating the landscape; in moonlit views it lies deep in shadow. In more distant views of the Vale of Matlock, Wright attends to the geological depths of the landscape and its mineral resources, in the foreground of one a tilted cart used for unloading rocks from a quarry (fig. 57), on the skyline of another the chimney of a lead mine.

These views are part of a series by Wright of sites along the Derwent valley and its tributaries. Arkwright's mills glowing at night (fig. 44) were as much a tourist spectacle as Matlock Tor glowing by day. Wright charts the power, prosperity and progress represented by the sites and scenery. In local, partisan accounts of Derbyshire, such as James Pilkington's *View of the Present State of Derbyshire*, Wright's works are included with those of the various industrialists and intellectuals of the region. Those who have seen its scenery 'touched by the sweet and magic pencil of Mr Wright of Derby, will easily conceive, how deserving they are of the attention which has been paid to them'. In a poetic *Address to the River Derwent* celebrating Darwin's move to Derby, Francis Mundy surveyed the 'radiant state' of a river valley so blessed with such enlightenment.

Derbyshire's glamorous and somewhat mysterious reputation as a site of scenic tourism and scientific investigation extended beyond Britain, and the customary standards of landscape comparison were reversed. By the 1780s Switzerland was being described as the Derbyshire of Europe. Mountains and caverns, mines and mills, were the loci of speculative enquiry. Wright made detailed plans to paint a scene from John Sargent's dramatic poem *The Mine* (1785) which incorporated natural philosophy, including Whitehurst's geology and Priestley's chemistry, in a Rosicrucian tale of enlightenment set in an Idrian mercury mine. Unjustly imprisoned in the mine, a nobleman is released by 'beams of mercy' from 'spirits of the earth' performing their 'high alchymy', brewing various metals, ultimately spiritual gold. They transform his 'gloomy prison house' into a radiant landscape of mountains, meadows, lakes and waterfalls.

> In earth's brute caverns we can wake delight
> And gild with rapture the dark brow of night.

Matlock Tor perhaps provided a model for the landmark in Wright's lost painting, *View of Gibraltar during the Destruction of the Floating Spanish Batteries* (1785). The successful defence of Gibraltar, under siege during 1779–83, captured the public imagination, and the defeat of a Catholic

58 *View in Dovedale* 1786. Oil on canvas 45.7 × 63.5 (18 × 25)
Trustees of the Kedleston Estate Trusts

59 *Convent of San Cosimato and part of the Claudian Aqueduct near Vicovaro in the Roman Campagna*
*c.*1786. Oil on canvas 76.2 × 63.5 (30 × 25). Trustees of the Kedleston Estate Trusts

power delighted radical patriots. Wright drew on descriptions of the event to paint what was by all accounts one of his most spectacular scenes. Wright himself described how the burning batteries of the Spanish 'make a fine blaze, and illuminate in a striking manner the noble Rock of Gib[ral-tar]'. Wright considered raffling the painting, which he exhibited at a one-man show in 1783. It was eventually sold to one of his main patrons, the Wakefield wool merchant John Milnes, for £420, the highest price of any of Wright's paintings during his lifetime. In some verse for the catalogue William Hayley declared

> This miracle of art a Briton wrought
> Painting as boldly as his country fought.

In his *Ode to Wright* Hayley contrasted the patriotism of Wright's painting with his rejection by the Royal Academy:

> Where Art, whom *Royalty* forbade to roam,
> Against thy talents closed her self-dishonour'd Dome.

Wright's later landscapes were shaped by his walking excursions into the English countryside, many of them specifically undertaken as a therapy for his depression. He made excursions with the Reverend Thomas Gisborne, one of the flourishing breed of clerical observers of countryside. After a brilliant career at Cambridge, Gisborne chose to return to his home territory in Needwood Forest between Derby and Lichfield where he pursued his interests in sketching and birdwatching, composing sermons, poetry and moral tracts. In 1786 Wright painted companion views of Dovedale and the Anio valley in the Roman *campagna* (figs. 58 and 59), perhaps to prove that the Midlands had scenery as fine as that of Italy; also a portrait of Gisborne, in clerical black satin, holding a portfolio of sketches, sitting with his wife beneath a grove of trees representing Needwood Forest and Gisborne's regard for it (fig. 35).

Gisborne celebrated forest scenery for its natural beauty and social order. He promoted the liberal virtues of cultivation and trade but called for government to regulate too aggressive a commercial spirit, in enclosure, the slave trade and the factory system, to conserve a divinely ordained harmony of nature and human nature. Gisborne's views of scenery and society exercised a powerful influence on landscape aesthetics in the later eighteenth century, especially on William Gilpin (recalling him to the pastoral duties and picturesque beauty of the New Forest) and recent theorists of the Picturesque such as Uvedale Price.

There are exchanges between Wright's art and Gisborne's writings. In *Walks in a Forest* Gisborne upholds the clear compositional and explana-tory structure of Wright's nocturnes of Vesuvius (one of which he owned) with the disconnected, motley-hued, consciously painterly efforts of a new generation of landscape painters.

> Ye sons of imitative art who hang
> The fiction of your pencils on our walls
> And call them landscapes.

60 *Cottage on Fire*
*c.*1787
Oil on canvas
58 × 76.2
(22⅞ × 30)
Minneapolis
Institute of Arts

On Gisborne's wall was the real thing:

> Mark the burst
> Of brightness from the roaring crater mount
> To Heaven; and behold the electric flash oblique ...
> Watch the red deluge o'er the works of man,
> hamlets and cities, towers and cultivated plains.

Wright's late series of nocturnes of woodland cottages on fire (fig.60) correspond to an episode in *Walks in a Forest*, which Gisborne may have related to him during their excursions. The poet encounters traces of a ruined dwelling in a clearing and tells the 'story of a cottager' whose life was ruined by a 'fiery deluge'. Permitted by the forest officials to build a cottage and cultivate a plot with 'his industrious spade', the cottager reared a family, a model of domestic virtue. 'One unhappy night' careless foresters burned the fern to create pastures and the wind fanned the flames towards the cottage:

> The fiery vollied sparks, the pillar'd fire,
> Burst from the thatch. Onward he rush'd to save
> What more than life he loved. At once the cot
> Sunk; higher towr'd the flame: wife, husband, babes,
> One ruin whelm'd; one grave their bones received.

The moral of this story is a conservative one, in the style of Edmund Burke's counter-revolutionary writings of the 1790s, that inflammatory forces threatened carefully nurtured structures. The fiery deluge in the forest threatens both the humble cottage and the 'mighty oak'.

Gisborne's appropriation of Wright's art, to a clerical, conservative vision of a landscape, was one poetic possibility. In his more radical poem *The Botanic Garden*, Darwin placed his descriptions of Wright's art in a passage on the prickly virtues of Ilex, the Holly, noting how the famous clumps of hollies in Needwood Forest, 'armed with thorny leaves about eight feet high', both protected the ancient trees and acted as landmarks: 'lead the lone pilgrim through the trackless glade, Or guide in leafy wilds the wandering maid'.

61 *Ullswater*
*c.*1795
Oil on canvas
46.3 × 53.7
(18¼ × 21⅛)
The Wordsworth Trust

> So Wright's bold pencil from Vesuvio's height
> Hurls his red lavas to the troubled night;
> From Calpe starts the intolerable flash,
> Skies burst in flames, and blazing oceans dash; –
> Or bids in sweet repose his shades recede,
> Winds the still vale, and slopes the velvet mead;
> On the pale stream expiring Zephyrs sink,
> And Moonlight sleeps upon its hoary brink.

In 1794 Gisborne persuaded Wright and his daughters to join a sketching party to the Lake District to lift the painter's spirits from a protracted depression during which he had abandoned his art. Wright returned from the Lakes revived,

> after having explored the most stupendous scenes I ever beheld, they are to the eye what Handel's choruses are to the ear. The best parts of Derbyshire suffer much by comparison: there it is beautiful nature on a small scale, here all is grandeur and magnificence, mountains piled on mountains & tossed together in wilder form, than imagination can paint or pen describe – To have done these scenes justice I should have visited them twenty years ago, when my mind & body were more vigorous.

Like any self-respecting tourist, Wright appears to have taken Gilpin's guidebook on the Picturesque to the Lakes with him, or at least consulted it when he returned to his studio, for the style of his paintings of the Lakes reflects Gilpin's recommendations. Wright's painting *Ullswater* (c.1795) (fig.61) recalls Gilpin's own 'Description of Ullswater under conditions of perfect calm': 'The sun was descending low, and cast the broad shades of evening athwart the landscape, while his beams, gleaming with yellow lustre through the vallies, spread over the inlightened summits of the mountains, a thousand lovely tints ... The air was still, the lake one vast expanse of crystal mirror.' Nothing Gilpin encountered was 'so beautifully

62 Landscape with a Rainbow 1794
Oil on canvas
81.2 × 106.7
(32 × 42)
Derby Museum and
Art Gallery

sublime, so correctly picturesque as this ... Here you see nature in her full dimensions ... You are let into the very mystery – into every artifice, of her pencil.'

In getting to landscape, Wright did not abandon his earlier artistic or cultural preoccupations. One of his last works, *Landscape with a Rainbow* (1794) (fig.62), focuses the full range of his art. Our eye follows a cart emerging from the foreground of a wood. This forms a circular, lens-like opening on the scenery beyond. The cart is about to cross a rushing river over a brilliantly lit bridge, heading along the road in the direction of the rainbow. Rainbows were rich religious symbols, of hope for mankind after Noah's Flood, of Christ's new covenant of mercy. In the eighteenth-century poetry which Wright so often drew upon, the rainbow is seen in terms of Newton's explanation of the refraction of light, to the point where it figures the power of Newton's vision. In *The Pleasure of the Imagination*, Akenside describes how the rainbow's colours never seemed so pleasing until:

> The hand of Science pointed out the path
> In which the sunbeams, gleaming from the west,
> Fall on the watery cloud ..., whose darksome veil
> Involves the current; and that trickling shower
> Piercing through every crystalline convex
> Of clustering dewdrops to their flight opposed,
> Recoil at length where, concave all behind,
> The internal surface of each glassy orb
> Repels their forward passage into air;
> That thence direct they seek the radiant goal
> From where their course began; and, as they strike
> In different lines the gazer's obvious eye,
> Assume a different lustre, through the brede
> Of colours changing from the splendid rose
> To the pale violet's dejected hue.

Wright's rainbow also describes the arc which structures the spatial composition of so many of his pictures, of both interior and exterior scenes, giving them a vaulted, voluminous quality and emphasising the creative, shaping power of the light within. In the posthumous sale of Wright's works at Christie's in 1801, the painting was called *Landscape with a Rainbow: View Near Chesterfield in Derbyshire*, the subtitle presumably added by one of Wright's circle of family, patrons and friends. A location near the Derbyshire town has not been verified, and the subtitle has been dropped, but the ingredients, the cart, road, bridge and radiant landscape, are characteristic of his landscapes of the Derbyshire Dales, and like them frame a series of speculations which extend well beyond the region.

In the last few months of Wright's life, according to his close friend and patron John Leigh Philips, landscape was the painter's 'continual study ... which occupied his mind at all times'. Shaking hands and failing eyesight forced Wright to work on small canvases and frustrated his attempts to portray new effects. In the end he was bedridden with a number of painful ailments – spasmodic asthma, liver disease, suspected dropsy and chronic depression – so shortsighted, noted Philips, 'that he scarcely knows a

person across a room'. Despite the best medical care by Erasmus Darwin, Wright died in August 1797, aged 63.

Travelling through the Midlands in January of the previous year, the poet Samuel Taylor Coleridge wrote that 'Derby is full of curiosities ... the cotton, the silk mills, Wright, the painter, and Dr Darwin.' The particular association of Wright with Derby and its industrial culture was to become more strongly forged after the painter's death, indeed it was to be the basis of a revival of his reputation towards the end of the nineteenth century. After nearly a century of neglect, Wright was hailed as a local hero, his work esteemed as a monument to provincial civic pride. Derby Corporation built up an unrivalled collection of his work; exhibitions displayed his paintings alongside industrial products and scientific apparatus; he was applauded for the matter-of-fact realism of his approach. Since then the study of Wright has undergone a series of scholarly and popular revisions, his work repositioned in the world of eighteenth-century art and culture as it reflected twentieth-century concerns. He was given a pivotal place in Francis Klingender's *Art and the Industrial Revolution*, first published in 1947, one of a number of wartime studies which championed the spirit of Enlightenment culture in Britain and its power for international progress. Benedict Nicolson's monograph of 1968, *Joseph Wright of Derby, Painter of Light*, presented a greater range to Wright's work, but tended to regionalise the painter in a restrictive way. In the wake of Nicolson's study, Wright was enthusiastically taken up by academics abroad who searched out the symbolism of his art. The Tate Gallery's major retrospective of 1990, held in New York and Paris as well as London, promoted Wright's international stature, part of the Gallery's policy of elevating the progressive role of 'regional voices' in British art. The recent chapters on Wright by Ann Bermingham, David Solkin and myself in more general books on art and culture have opened up the breadth of historical references in Wright's art which frame some of the political issues of the recent past, notably consumer culture, gender and national identity. In the process Wright emerges as a more metropolitan figure. The recent bicentenary exhibition of 1997 in Derby and the opening of a splendid new gallery for the display of its unrivalled permanent collection inevitably repatriated Wright for the town and its tourist promotion, in the same way as other painters like Lowry and Miró have recently been reclaimed for Salford (Manchester) and Palma (Majorca) respectively. The Derby exhibition and accompanying catalogue also revealed a rich new seam for research in Wright's drawings and figure studies, many done in London and Italy. More than ever, Wright's art both invites and escapes any simple identification with particular concerns or particular places. This is surely a source of its appeal and currency. At the end of the twentieth century, as we are conscious of a shifting world, and citizens in contemporary Britain, like those of Wright's time, review their culture and identity in terms of a new Europe, the range and depth of Wright's art appear compelling.

Chronology

1734

Joseph Wright born Derby, 3 September, third of five children, to Hannah Brookes and John Wright, attorney and Town Clerk of Derby.

1745

Wright's family leave Derby for Repton when Jacobite army arrives in town. Aged 11, Wright takes up drawing.

1748

Earliest surviving work: three chalk drawings, copies of prints.

1751

Formal training as artist begins with two-year apprenticeship as a portrait painter under Thomas Hudson in London.

1755

Returns to Derby. Earliest dated portrait, *Anne Bateman.*

1756–7

Resumes training in London with Thomas Hudson for further fifteen months. Strikes up enduring friendship with fellow-student John Hamilton Mortimer. Socialises with Mortimer and other young artists at the Howdallian Society.

1757

Returns to Derby to establish a portrait painting practice. Clients from throughout East Midlands.

1762–3

Portraits of members of the Markeaton Hunt exhibited at Derby Town Hall.

1765

First exhibits at the Society of Artists, showing *Three Persons Viewing the Gladiator by Candlelight.* Portraits include *Peter Perez Burdett and his wife Hannah.*

1766–9

Exhibits at the Society of Artists include *A Philosopher giving that Lecture on the Orrery, An Experiment on a Bird in the Air Pump* and *A Philosopher by Lamp Light.* Reputation established through fine prints as well as exhibits. Reviewer for *Gazetteer* pronounces Wright 'a very great and uncommon genius, in a peculiar way'. First indications of clinical depression.

1768–71

From end of 1768 to autumn 1771 chiefly based in Liverpool. Portraits include *Mrs Sarah Clayton.* Summer 1770 in Lichfield painting portraits of Thomas Day and Erasmus Darwin; also decorates room at Radbourne Hall with John Hamilton Mortimer.

1771–3

Exhibits at Society of Artists include two versions of *A Blacksmith's Shop, An Iron Forge, An Iron Forge viewed from without, The Alchymist* and *The Earthstopper.*

1773

Marries Hannah [or Ann] Swift in July. Departs for Italy in October via Spain and Nice.

1774

Arrives in Rome in February. First child Anna Romana born June. Visit to Naples early October to mid-November.

1775

Begins journey from Rome to England via Florence, Venice, Vicenza, Turin, Parma, Lyons, Paris. Arrives Derby 26 September.

1775–7

From late 1775, for twenty months or so, in Bath, where he fails to establish himself as portraitist.

1776

Exhibits a *Vesuvius* and *Girandola* at Society of Artists.

1777

Returns to Derby and lives there until his death. Lodges with surgeon brother Richard, then in 1779 moves into St Helen's House on the edge of the town.

1778–82

Exhibits for first time at Royal Academy. Pictures include *An Eruption of Mount Vesuvius with ... St Januarius's Head* and *Grotto ... with Banditti, Brooke Boothby* and *Maria, from Sterne.*

1780

First son Joseph dies aged 3.

1783

First recorded bout of depression which prevents Wright painting for weeks on end, although the illness seems to have begun sixteen years earlier.

1783 4

Quarrels with Royal Academy. Exhibits only at Society for Promoting the Arts in Liverpool.

1785

One-man exhibition at Robin's Rooms, Covent Garden; works include *The Corinthian Maid, Penelope Unravelling her Web by Lamp-Light, The Indian Widow, John Whitehurst, View of Gibraltar.*

1786

Paints *Rev. Thomas Gisborne and his wife Mary*

1787

Exhibits at Society for Promoting the Arts in Liverpool. Onset of clinical depression.

1788–9

Exhibits again at Royal Academy; mainly Italian subjects.

1789

Quarrels with Boydell's Shakespeare Gallery over price for two pictures.

1790

Quarrels again with Royal Academy. Paintings include portraits *Sir Richard Arkwright, Jedediah Strutt, Landscape with Figures and a Tilted Cart, Italian Landscape.* Wife dies aged 41. Wright moved out of St Helen's House into one in Queen's Square, Derby.

1791

Bouts of depression and liver disease prevent Wright painting

1794–5

Excursion to the Lakes. Paints *Rydal Waterfall, Ullswater* and *Landscape with a Rainbow.*

1797

Wright dies 24 August, few days short of his 63rd birthday. Buried St Alkmund's Church, Derby.

Bibliography

Bemrose, William, *The Life and Works of Joseph Wright ARA, Commonly Called 'Wright of Derby'*, London and Derby 1885.

Bermingham, Ann, 'The Origin of Painting and the Ends of Art: Wright of Derby's *Corinthian Maid'*, in John Barrell (ed.), *Painting and the Politics of Culture*, Oxford 1992, pp.135–66.

Bermingham, Ann, and Brewer, John (eds.), *The Consumption of Culture 1600–1800: Image, Object, Text*, London 1995.

Boime, Albert, *Art in an Age of Revolution 1750–1800*, Chicago 1987

Brewer, John, *The Pleasures of the Imagination: English Culture in the Eighteenth Century*, London 1997.

Clayton, Timothy, *The English Print 1688–1802*, New Haven and London 1997

Craske, Matthew, *Art in Europe 1700–1830*, Oxford 1997.

Craven, Maxwell, *Derby: History and Guide*, Stroud 1994.

Craven, Maxwell, *John Whitehurst of Derby: Clockmaker and Scientist 1713–88*, Ashbourne 1966.

Cummings, Frederick, 'Boothby, Rousseau and the Romantic Malady', *Burlington Magazine*, vol.110, 1968, pp.659–66.

Cummings, Frederick, 'Folly and Mutability in two Romantic Paintings: The Alchemist and Democritus by Joseph Wright', *Art Quarterly*, vol.33, 1970, pp.475–81.

Daniels, Stephen, 'Joseph Wright and the Spectacle of Power', in *Fields of Vision: Landscape Imagery and National Identity in England and the United States*, Cambridge 1993, pp.43–79.

Daniels, Stephen, 'Loutherbourg's Chemical Theatre: *Coalbrookdale by Night*', in John Barrell (ed.), *Painting and the Politics of Culture*, Oxford 1992, pp.195–230.

Egerton, Judy, *Wright of Derby*, London 1990.

Eitner, Lorenz, 'Cages, Prisons and Captives in Eighteenth-Century Art', in Karl Kroeber and William Walling (eds.), *Images of Romanticism: Verbal and Visual Affinities*, New Haven and London 1977, pp.13–38.

Fraser, David, 'Fields of Radiance: The Scientific and Industrial Scenes of Joseph Wright', in D. Cosgrove and S. Daniels (eds.), *The Iconography of Landscape*, Cambridge 1988, pp.119–42.

Hamblyn, Richard, 'Private Cabinets and Popular Geology: The British Audiences for Volcanoes in the Eighteenth Century', in Chloe Chard and Helen Langdon (eds.), *Transports: Travel, Pleasure and Imaginative Geography, 1600–1830*, New Haven and London 1996, pp.179–206.

Jacob, Margaret C., *The Radical Enlightenment: Pantheists, Freemasons and Republicans*, London 1981.

Jones, Rica, 'Wright of Derby's Techniques of Painting', in Judy Egerton, *Wright of Derby*, pp.263–72.

Klingender, Francis, 'Joseph Wright of Derby', in *Art and the Industrial Revolution*, rev. edn., ed. Arthur Elton, London 1968, pp.37–56.

Nicolson, Benedict, *Joseph Wright of Derby, Painter of Light*, 2 vols., London 1968.

Nicolson, Marjorie Hope, *Newton Demands the Muse: Newton's Opticks and the Eighteenth Century English Poets*, Princeton 1946.

Paulson, Ronald, 'Wright of Derby: Nature Demythologized', in *Emblem and Expression: Meaning in British Art of the Eighteenth Century*, London 1975, pp.184–203.

Porter, Roy, 'Science, Provincial Culture and Public Opinion in Enlightenment England', *British Journal for Eighteenth Century Studies*, vol.3, 1980, pp.21–47.

Porter, Roy (ed.), *The Enlightenment in National Context*, Cambridge 1981.

Postle, Martin, *Angels and Urchins: The Fancy Picture in 18th-Century British Art*, Nottingham 1998.

Schaffer, Simon, 'Natural Philosophy and Public Spectacle in the Eighteenth Century', *History of Science*, vol.21, 1983, pp.1–43.

Shawe-Taylor, Desmond, *The Georgians: Eighteenth Century Portraiture and Society*, London 1990.

Solkin, David, 'Joseph Wright and the Power of the Aesthetic', in *Painting for Money: The Visual Arts and the Public Sphere in Eighteenth Century England*, New Haven and London, pp.214–46.

Wallis, Jane, *Joseph Wright of Derby 1734–1797*, Derby 1997.

Photographic Credits

Index

NOTE: References in italics denote illustrations.